If *we're standing on the* SHOULDERS of giants, *what are we* REACHING *for?*

EMIGRE

Co-published by
PRINCETON ARCHITECTURAL PRESS

Edited and designed by Rudy VanderLans.
Copy editing by Alice Polesky.

Emigre, 1678 Shattuck Ave., #307, Berkeley, California 94709
Visit our web site at www.emigre.com.

Co-published by Princeton Architectural Press
37 East Seventh Street
New York, New York 10003
For a free catalog of books, call 1.800.722.6657.
Visit our Web site at www.papress.com.

Printed and bound in the USA in an edition of 6,000 copies.

06 05 04 03 5 4 3 2 1 First edition

ISBN 1-56898-433-2
ISSN 1045-3717

Literature

FOR GRAPHIC DESIGNERS

CONTENTS

TURN UP THE NOISE

It is often argued that graphic design is most valuable when it addresses specific needs. Like plumbers or dentists, we must find solutions to problems. Anything else is just noise, distracting us from what really counts.

So, too, in the world of typeface design; a division exists between what is useful and what is useless, based on how well people are served by your work. When you design "serious" text typefaces, for instance, there is an automatic assumption you will serve the needs of the masses well. Highly legible text typefaces lead to clear typography, which leads to non-mediated, honest messages, which contribute to the betterment of society. Problem solved.

On the other hand, when you design display type, or anything that cannot be easily classified as a text typeface, you're a self-indulgent artist expressing yourself and making a quick buck, all at the expense of communication.

The problem with this argument is that in terms of the design of new text typefaces, we are no longer addressing needs, and are well into the realm of addressing desires. We have long ago produced all the text typefaces we need — and the typographic principles to use them properly — in order to produce texts of the highest readability. We figured this out centuries ago. Therefore, the contemporary designer who spends his or her time designing highly legible type is doing no more of an important or useful job than the one creating so-called headline or display type. S/he may be doing a more difficult job, but the act of drawing text type

is largely a self-serving pastime. And I don't see anything wrong with that. It is a human impulse to create, and dedication to one's art is to be encouraged and rewarded.

When Zuzana Licko coined the phrase "People read best what they read most" (*Emigre* #15, 1991), she was pointing out that what makes certain typefaces easier to read than others is our familiarity with them, more so than their intrinsic legibility. She arrived at this idea from the simple observation that our most common letterforms have changed dramatically over time. Before the invention of movable type most texts were handwritten, and by the beginning of the 21st century, we easily read bitmapped typefaces on computer screens.

Her statement was not a critique of the classics. On the contrary, it was an argument against creating new typefaces and sticking with what we have. If we believe in the benefit of universal typographic standards and a typographic world without affectations or cultural specificities, then there is really no need to reinvent the wheel. If we are convinced that easy accessibility and readability of texts is of the utmost importance, then we should simply use typefaces that have long, established track records of usage, such as Times Roman, Baskerville, Courier, and Helvetica.

But new text typefaces are being created continuously at a pace that has significantly increased ever since the arrival of type design software, such as Fontographer and FontLab. However, there's very little evidence that this increase in text type satisfies any special needs. No matter how professionally produced, rarely do the makers offer scientific proof that these new fonts will function any better than the models they are often based on. Instead, they're usually accompanied by claims about purity, historical accuracy, and a dose of professional snobbery and territorialism. But in

the end, all they offer to prove their case is personal bias.

There are exceptions, of course. For example, Euroface, the font designed to replace all road signage throughout the European Union, once and for all omitting culturally-specific characteristics, was the product of rigorous testing. However, the results were vehemently disputed by type and legibility experts from around the world. Obviously, when it comes to legibility and readability, objective standards are hard to come by.

Let's face it: whether you develop headline or text type, we all contribute to a typographic Tower of Babel. Zuzana Licko understood this when she started designing typefaces. She also recognized that the reasons new text types are created are the same reasons that new non-text types are created, which are the same reasons we design almost anything: we have a desire to differentiate, to stand apart. But mostly we do it because as human beings we like making things, and we enjoy showing our personal quirks, technological obsessions, or our cultural heritage through our work. And it would be disingenuous to omit economic incentive. Typeface design can be a lucrative occupation when practiced with the right combination of skill, talent, honesty, and dedication. Such work should be rewarded.

To think of the design profession simply in terms of how it solves problems or fulfills specific needs is missing the point. Design and type design alike have a lot more to offer. When graphic designers are asked what inspires them, they often show examples of vernacular work. Handmade signs, deteriorated letters on a store front, the accidental collages of torn, overlapping billboards, etc. Herbert Spencer filled many pages of his *Typographica* magazine with photos of such vernacular work. *Pentagram Papers*, a small publication infrequently published by Pentagram, is filled with examples

of "low culture." *U&lc* in its heyday often showed the private collections of graphic designers that usually contained found objects displaying the funkiest of typefaces and graphics. All of a sudden, bad letter spacing is no longer an issue. Purity of form is inconsequential. Poor craftsmanship is a curiosity worthy of collecting. Why? Designers understand the importance of this work because they know that the indigenous qualities inherent in vernacular design resonate with audiences on a level far beyond the fulfilling of needs. What matters is the soul of the thing. All graphic designers secretly wish they could make such work themselves.

Obviously, there is nothing wrong with fulfilling needs. But we serve the needs of our audiences even better by being honest about our work, and by admitting there are no simple answers to questions like whether text type has more value than headline type. Much of what we produce as designers is, indeed, just noise. But if done with love and care, it can be a beautiful sound.

I'm sure I sound like a broken record. The above has been stated before in one form or another in the pages of *Emigre* magazine. But I feel it needs stating again. Increasingly now, I come across mention of the death of Post-modernism and what a short fling it was — a sordid love affair with nothing to show for it. The traditionalists notice a decline in the use of "grunge" fonts, and they're celebrating the decay of Deconstructivism. They're dancing in the aisles. The tides have turned. It's all about kerning and smooth curves and clarity again — and Helvetica for everybody! This is silly of course, because design is made up of all these movements, all the time, everywhere you look.

I've never cared much for the strict categorization of design into Modernism, Post-modernism, Deconstructivism, or any "ism" for that matter. Each seems too restrictive and

too all-encompassing at the same time. And when anybody uses such a term, I am never sure what exactly it means to them. Are they talking about particular stylistic manner-isms, methodologies, philosophies, or the idealism that sprouted these movements?

I have a small note attached to the wall right above my computer. It's a quote by Robert Venturi that reads, "To be modern is to be dissatisfied with current conditions." I like that quote. And if that's the essence of being modern, then I'm as much a Modernist as Paul Rand (or, to appease our European readers, Wim Crouwel). I also remember Ellen Lupton's statement, that Deconstructivism is a form of ques-tioning.* I like that idea, too, because now and again I see a need to question the principles of design. I also like to delve into the past on occasion, and mix elements of it into my work. How can you not? Aren't we all standing on the shoul-ders of giants? Does that make me a Post-modernist? Anyway, you get the idea. When it comes right down to it, the work of most graphic designers can invariably be fitted into any of these categories. And if that idea makes me a relativist, so be it.

It is probably best to omit these words from our vocabu-laries. Like the value judgments that non-text fonts are less useful than text fonts, these terms have a tendency to over-simplify and obscure more than they reveal. If we must celebrate the demise of anything, let's celebrate doing away with these terms, since they are mere shortcuts for thinking deeply about design.

In this second issue of *Emigre*, presented in our new book format, we hope to do some deep thinking about topics that are close to our hearts. As evidenced by my preceding rant, typefaces is one of them. As the cornerstone of most graphic

design, type remains an inexhaustible source of discussion.

We look at the phenomenon of Helvetica, and the fact that this nearly 50 year-old sans serif is currently one of the three best selling fonts at many of the world's largest font distributors. Today, it is once again the font of choice (did it ever really go away?) But, as ten different designers tell us, not everybody is using it for the same reasons.

We are also reprinting the article "Legible?" which was published in *Emigre* #23 and written by the well-known Dutch type designer Gerard Unger. This is the first time we have ever reprinted an article from a previous issue. The reason is as simple as it is embarrassing, and yours truly tries to explain.

Then, Elliott Earls, who is not your garden-variety type designer and has some very specific ideas about how to draw type, gives us his unique outlook on what matters most when designing a typeface.

Another topic that *Emigre* loves to sink its teeth into is that of design trends and styles, what they mean, and what their implications are. This time we satisfied our appetite by interviewing Rob Giampietro, who has coined the term "Default Systems Design" to describe a particular type of design that is rapidly spreading and is begging to be put under a microscope.

Meanwhile, recent Cranbrook design graduate Joshua Ray suggests that we should stop obsessing about such phenomena and instead focus on the extraordinary position of graphic design within our culture. He urges us to exploit this powerful position to create something of value. He does his hilarious utmost to convince us that design styles are not where the action is.

Also, we are featuring four short essays written in reply to our previous issue: Mike Kippenhan addresses graphic

design's aversion to criticism and suggests we look at American Idol as a model to kick-start the comatose state of design inquiry; Patrick Fox tells us how *pro bono* work can keep an out-of-work graphic designer from committing desperate acts; Anthony Inciong ponders the responsibilities of graphic design education in an age defined by the tyranny of style and technology; and, finally, Armin Vit fires off a short essay in reply to the challenge put forth by the "old cranks" in "Rant." He may not be speaking for an entire generation of young and upcoming graphic designers, but I have a suspicion many of his contemporaries will agree with what he has to say.

Hope you like the ride.

Rudy VanderLans

* Here I'm paraphrasing. If I'm wrong, or I oversimplify, my apologies to Ellen.

P.S.: A lengthy and heated discussion regarding our previous issue (*Emigre* #64, Rant) took place in the Book Club section at Armin Vit's *Speak Up* site: http://www.underconsideration.com/rant/

16

HELVETICA AGAIN

Within graphic design there are always undercurrents at play where new ideas and methodologies are being tried out. They push, pull, question, and react to what we take for granted within our profession. The driving forces behind these movements are usually young designers and design schools looking for new ways to communicate in voices that speak to the cultural, social, and technological concerns of our times. Often these experiments are first supported and dispersed by youth culture magazines, self-published printed ephemera, and websites.

When these new ideas reach critical mass (i.e., when their visual manifestation has been decoded and they become more widely implemented), they are then quickly co-opted by the mainstream. Here they are stripped of their ideology and referred to as new visual trends or styles. Established graphic design and advertising companies, which have little time to explore and develop new visual languages themselves, appropriate these new trends in order to communicate more effectively with their target audiences. They, too, try to connect with the cultural concerns and habits of their audiences, except on a much larger scale, and usually for profit.

When this co-option by the mainstream happens, completing the style cycle, a new undercurrent is usually about to reveal itself. It's a continuing process. Yet whether you are right in the middle helping to develop the next big thing, or on the outside looking out for it, you never recognize it as anything of significance until it has been firmly established, at which point it's on its way out.

One such recent trend that went from underground to mainstream is an approach signified by the use of an old standby typeface, Helvetica. We touched upon this in our previous issue. For the past three or four years, Helvetica has consistently been one of the three best selling fonts for a number of large type distributors. In order to

better understand why this typeface, which was designed in 1956 by Max Miedinger,* has become so popular again, *Emigre* interviewed a wide spectrum of graphic designers (young to old, experimental to mainstream) whose work of the past few years instigated and underscored this renewed interest in Helvetica.

RVDL.

* Then called "Neue Haas Grotesk"

EXPERIMENTAL JETSET

Holland

Why do you use Helvetica?

There are many reasons why we use Helvetica. Each is very different and sometimes seemingly contradictory, and they slowly but constantly change. Some of these reasons may be hard to follow, but we like to believe that it is exactly the complicated nature of our reasoning that, paradoxically, makes our designs so practical and clear.

One of these reasons involves Helvetica's neutrality. Of course, we fully realize that no typeface is neutral, and that Helvetica's objectivity is a myth. But it is exactly this myth that turned Helvetica into one of the most widely used typefaces in the first place. So it is fair to speak of a myth that created its own reality. In that sense, Helvetica's neutrality resembles a self-fulfilling prophecy. This neutrality, real or imagined, enables us and the user to fully focus on the design as a whole, neutralizing the typographic layer as a way to keep the concept as clear and pure as possible. There are cases, however, where for specific reasons, the concept demands a less neutral typographic layer. In those cases we never hesitate to use other typefaces. But those cases are rare.

What do you think Helvetica signifies?

The fact that we ascribe a certain neutrality to Helvetica doesn't mean that we believe that the typeface signifies nothing but itself. But we do think that most of what Helvetica signifies exists primarily within the specific context of graphic design. Helvetica refers mostly to graphic design itself. And this self-referentiality is yet another reason why we use Helvetica. In our work, we constantly try to underline the physical qualities of graphic design. By stressing the idea of design as matter rather than as an accumulation of images, we try to get away from the alienation of visual culture.

Just to be clear, when we talk about "images" we don't mean illustrations or pictures; we mean representations, or projections. For example, a "grungy" typeface that is used specifically to attract a "grungy" audience is, for us, an image or a "representation."

(By the way, we have nothing against grungy typefaces per se. When the inner logic of a certain design demands a specific type-

face, so be it. But if that grungy typeface is used only to reflect a certain target audience's presumed lifestyle, then we have a problem with it. Because in that case, graphic design is reduced to a representative, immaterial layer that hides more than it reveals.)

For us, one of the many ways to underline the physical, material qualities of a design is through the use of self-reference. The referring of an object to itself or to its own context can be seen as a form of "materialization." To quote the British conceptual art collective Art & Language: "In order to perforate art with reality, it [art] has to be folded back into itself."

We think the same can apply to graphic design. Using Helvetica, with its self-referential qualities, helps us create designs that function as a part of reality instead of as a representation of reality. In short, one of the reasons why we use Helvetica is this self-referential attribute.

> Isn't everything you create a representation of some sort? My words are a representation of my thoughts. My thoughts a representation of my experiences...

Yes, and your experiences are formed by the world around you. We agree. But let's extend that line of thinking. Now imagine that the world around you is trying to be a representation of your thoughts. Wouldn't it just go round and round then, since you would only experience your own representation? We're not against representation in general. But we do think that a material environment that just tries to represent its audience will lead to some kind of cultural degeneration.

In our view, design should have a certain autonomy, an inner logic that exists independently of the tastes and trends of so-called target audiences. As the ways to measure the taste of the public are becoming more refined every day, culture is in real danger of turning into a gigantic mirror that offers nothing but a false reflection.

(When we talk about autonomy, it has nothing to do with whether an object is functional or not. For example, a paper clip represents absolutely nothing outside itself. It has a strong, almost hermetic, inner logic. But despite this, or, in our opinion, because of this, it is regarded as one of the most functional objects on earth.)

And this loss of autonomy is not only happening in design. Political parties, for example, are becoming more and more populist, losing the inner logic of their ideologies, and trying only to

reflect what the voters want on a day-to-day basis. So instead of politicians presenting a certain viewpoint that you can vote for or against, they first find out what the public wants and only then form their viewpoint, not based on a certain belief but just on daily trends.

Do you use Helvetica to show allegiance to a certain approach or ideology?

There are without doubt links between our use of Helvetica and the fact that we are quite sympathetic towards a lot of the ideas of past Modernist movements. But these links are more complicated and indirect than some would expect. Our use of Helvetica is not some sort of direct formal tribute to the aesthetics of Modernism. It's not as simple as that. We have no affinity with formalistic retro-Modernism at all, as we find this kind of retro-Modernism distastefully Post-Modern.

If there is indeed a connection between our use of Helvetica and Modernism, it can be found in our ideas of design as matter. For us, one of the core beliefs of Modernism is the idea of "makeability": the concept of changing society through changing material circumstances. Our own attempts to rematerialize graphic design, by using Helvetica, for instance, can be seen as a manifestation of our own belief in this "makeability."

I'm not sure if I understand this. It would be easy to distill from this answer that you are saying that you hope to change society simply by using Helvetica. But I'm thinking that's not entirely what you're saying. Or are you?

We agree; this is where our reasoning gets complicated and we're not sure if we completely understand it ourselves. But by underlining the physical proportions, qualities, and inner logic of our designs, we try to stress the fact that they are objects. This may sound obvious and futile and not very revolutionary, but it's our humble way of resisting dissolution into a immaterialized visual culture in which there are only representations and the object is completely disconnected from its image. We try to go against this alienation by focusing on the idea of design as matter.

One way we try to stress the idea of design as an object is through this notion of self-reference, which we discussed earlier. By referring to itself or its context, the object gains some kind of "self-awareness"; it becomes an object in itself. We're not saying

everything should posses this self-referentiality; it's just one way to achieve this materiality. And one of the many possible ways to achieve this self-referentiality is the use of Helvetica, even though it plays only a small part in this scheme.

Can you give me a more specific example of a piece you've designed that accomplishes this?

A while back we showed you a "four-sided" letterhead. It showed the names of four different people who work together in the same space, but not necessarily with each other, on one piece of paper. The names were printed on the top front, bottom front, top back and bottom back. This way, it could be used in four different ways, depending on how you turned the paper. By using all "four" sides of the paper, we tried to underline the physical proportions of the design.

The typography (Helvetica) was used in a non-representative way. A representative way to use typography here would have been to "research" what a certain "target audience" wanted, then try to find a typeface that illustrated and reflected that certain feeling or mood back to this audience.

The reason we used Helvetica had to do with the fact that it didn't interfere with the concept. A more expressive typeface would have destroyed it. But also, the fact that Helvetica refers mostly to graphic design itself turned the letterhead into an almost "archetypical" letterhead, which made the concept of four letterheads printed on one piece of paper even clearer. We didn't use the piece of paper as a neutral background on which to merely print a representative image, neglecting its physical qualities. We tried to design a letterhead that would work as an object, a piece of paper that wouldn't deny its role as a piece of paper.

Would you agree that there is a renewed interest in Helvetica at the moment?

As a matter of fact, we don't think that there is a renewed interest in Helvetica at all. Although we're not particularly interested in today's trends and fashions in graphic design, from our point of view the revival of Helvetica reached its peak five or six years ago. What we noticed around then was that the designers we knew and who used Helvetica all had their own personal reasons to do so. All these reasons were very different, but often quite intelligent.

We can only speak for ourselves. And one thing we certainly

don't like is to superimpose our personal reasons for using Helvetica on graphic design in general, as some kind of model. We leave that kind of superimposing to the critics.

Are you familiar with the original ideology behind the design of Helvetica? As a designer, do you think it is important to be aware of this original ideology?

We are aware of the history and original ideology, but even if we weren't, it wouldn't make our use of Helvetica less valuable or honest or effective. The question implies that ideology is something that exists outside reality; that theory is something that exists outside practice. Our way of thinking is very different. Ultimately, the ideology of Helvetica is an intrinsic quality of the typeface itself. Using Helvetica is enough; that's all the ideology one needs. Plug and play.

For some reason, the question (and what it implies) reminds us of a certain illustration in *Days of War, Nights of Love*, an excellent book written and published by CrimeThink, an anarchist collective in the U.S. The illustration shows a chained man being lashed by another man with a whip. Superimposed on the chained man is the word YOU. On the whip, it says LANGUAGE, and superimposed on the guy holding the whip is the word IDEOLOGY.

Do you think that the way Helvetica is used by yourself and others — often very stripped down and restrained, almost default-like — is an easy way out typographically? Does it in any way signal a general disinterest in the finer details and art of typography?

To suggest that the way we use Helvetica is an easy way out typographically is ridiculous. Simply ridiculous. We spend an enormous amount of time spacing, lining, and positioning type. The fact that we use only a small variety of typefaces demands a certain discipline, a skillful precision, a focus on the finer details. It's certainly not a-different-typeface-for-every-occasion attitude. Now, that would be an easy way out.

When a composer writes a piece for a limited amount of musicians, would that be an easy way out? When a director writes a play for a limited amount of actors, would that be an easy way out? Of course not. Likewise, designing with a limited number of typefaces is definitely not an easy way out. To suggest that it is would be a travesty.

Any final words?

You probably think we're completely out of our minds, as we realize all of the above might sound pretty bizarre. But as long as our complicated ideas translate into practical and functional designs, we're happy.

http://www.experimentaljetset.com/

IAN ANDERSON

The Designers Republic
U.K.

During most of The Designers Republic's existence, you lived through a huge backlash against Helvetica in the late 80s and early 90s. But you steadfastly held on to Helvetica. Then, Helvetica re-emerged as the hip font of the day. When this Helvetica resurgence happened, did this ever change your own feelings toward the use of Helvetica? In other words, were you ever concerned during this time that your work would be lumped in with what seemed like a stylistic fad?

We weren't aware there was a backlash — we must have missed that meeting. We're not really concerned with other people's opinions beyond the context of how we can utilize them to communicate our ideas more effectively. A fad is in the eye of the beholder; we reserve the right to be more than the sum of people's perceptions of our work. I don't have a lot of interest in someone who can't see more in our work than the use of a particular font.

Why do you use Helvetica?

Whether we use Helvetica purely æsthetically or purely tactically is for the viewer to work out.

What do you think Helvetica signifies?

I'm not sure it signifies anything universal. I'm aware that it is perceived as neutral. The enduring, often subconscious, legacy of Swiss Modernism in contemporary design perpetuates the notion that Helvetica is read best because it is read most.

Would you agree that there is a renewed interest in Helvetica at the moment? If yes, do you use Helvetica to show allegiance to a certain approach or style or to a certain ideology?

For most contemporary designers Helvetica is perceived as the default font and as such its popularity is dependent on creative action and reaction to a subjective sense of conformity. Much of the (renewed) interest in Helvetica is more about analysis of its prevalence in visual communication and consequent relevance to contemporary culture in the context of our need to make sense of our "world." TDR uses Helvetica as a means to communicate the ideas behind our work. Simply that. Creatively our only allegiance is to ourselves.

As a designer, do you think it is important to be aware of the original ideology behind the design of a font such as Helvetica?

I think it's important to be aware that an ideology was implicit in its creation.

What do you think is the reason for this renewed interest in Helvetica?

The comfort of Modernism. The future seen from the past is always more optimistic and safe. We have a sense we already live in the future we were promised post-war and it is far from being the space-age labour-saving paradise predicted. It's dirty and fucked up and we're bored. Modernism will save you all. Strength and joy through Helvetica.

Do you think that the way Helvetica is used today — often very stripped down and restrained, almost default-like — is an easy way out typographically?

It can be. It depends what lies beneath.

Does this return to Helvetica and minimalism in any way signal a general disinterest in the finer details and art of typography?

Maybe it signals that the democracy of technology has spawned a breed with no idea what they're doing or why they're doing it, for whom possession of the means of production (hardware/software) is nine-tenths of being creative; which randomly can be a good thing in a way that an anally retentive typographer never could.

Maybe it's a double bluff...

Could it signify something else entirely?

A search for a truth? Or at least the "idea" of the search for truth. A sense that raw information has more value without any form of expression and/or decoration. As the default font, Helvetica suggests openness and honesty. Data is king in an I.T.-obsessed culture.

http://www.thepeoplesbureau.com

NILLE SVENSSON

Sweden Design
Sweden

Why do you use Helvetica?

It embodies clarity and simplicity, so it doesn't obscure the text too much. Of course it is as "designed" as any typeface, but it has a sort of anti-decorative quality to it, which means that when you use it there is an automatic focus on the text's content. More contemporary "information" typefaces, like Avenir, Frutiger, Meta, Praxis, etc, usually suffer from being either too bland or too quirky. Helvetica strikes a balance; it is formal without being perfect and instantly recognizable without looking odd. A text in Helvetica says: "I am information. I am not printed on this page for looks. I am meant to be read." So if that's your goal, it works wonderfully.

Would you agree that there is a renewed interest in Helvetica at the moment? If yes, do you use Helvetica to show allegiance to a certain approach or style or to a certain ideology?

Yes, it is clearly more popular now than, say, ten years ago. But its popularity is in decline, like anything that has been popular eventually will be. Today's use of Helvetica is part of the overall popular 70s design retro trend, I guess. When I teach at Stockholm's design schools, I see how the students are now struggling to come to terms with serifs, or they are hooking up with styles from the 80s, such as elaborately decorative fonts, Letraset-porn, and early desktop low-fi. In general, the design trends are moving to a more decorative and crafty, handmade kind of place.

When we use Helvetica, we use it with the intention of putting emphasis on the words. It's not like we actively try to walk in somebody's footsteps, even if at times we do. And really, it's not like there is a subcult around Swiss typography, like the one around surf/hot rod design. Or am I wrong?

What is Letraset-porn?

I guess you will know it when you see it.

Are you familiar with the original ideology behind the design of such typefaces as Helvetica? As a designer, do you think it is important to be aware of this original ideology?

I have a faint recollection of it, but I must say that I believe it has

little relevance when you design with it. Elements of visual culture slowly permutate every time they are used. The impact and "meaning" are constantly changing. You have to try to analyze what kind of impact the element — whether it is a typeface, symbol, color or whatever — will have in the context that you are using it and at the time you are using it. And it's not just about your own knowledge; it's also about the knowledge of your audience.

To me, the value of studying design history and designer biographies is that it is a reminder that all the designs that seem so fundamental (like Helvetica) were once just sketches in a sketch book. Learning how things came into existence, and the creative processes behind them, helps you realize that you yourself have the possibility of doing the same thing. And at the same time, learning about the ideas and methods of other designers is a sobering reminder of the amount of work and level of ambition that are actually needed to get there.

To summarize: You probably don't need to study Helvetica's history in order to use it successfully. But if you want to create tomorrow's Helvetica, it is probably a good idea if you do.

What do you think is the reason for the renewed interest in Helvetica?

It is threefold. First, it's part of the 70s retro trend of the late 90s. The popular use of Helvetica today is clearly influenced by the advertising and packaging design of the 70s. I think this is the kind of feel the majority of designers are trying to capture when using Helvetica, even if the connection is not so obvious to all. After all, it is Helvetica Neue that is popular.

Second, form follows fashion, and fashion is always heading towards its contradiction. When I started art school, it was all about David Carson and Deconstructivism. This was great, but before you knew it, the simplicity of the bold, colorful use of typefaces like Helvetica and Futura felt almost avant garde. The pendulum swung.

Third, there is also a trend visible in today's visual communication, and visual culture in general, which coincides with the first two reasons, but also exists on its own, which is much more vague but nonetheless important for the popularity of Helvetica. I will not try to define it here, so let's make things easy by saying that it is a trend of getting-to-the-point, of expressing a message clearly and boldly. In comparison with the Deconstructive era, whose design æsthetic was much more effective in conveying a feeling of ambigu-

ity and perhaps poetry, this to-the-point kind of communication demands more the kind of design that Helvetica-based typography can help you deliver.

Do you think that the way Helvetica is used by yourself and others — often very stripped down and restrained, almost default-like — is an easy way out typographically? Could it signal a general disinterest in the finer details and art of typography? Or does it signify something else entirely?

Sometimes I get the feeling that certain designers believe that using this typeface will automatically make it look like they know their way in typography, that it will work like some kind of "instant design." This sort of sloppy-slacker-Swiss typography is, as you imply yourself, a kind of style all by itself. So it might be justified in its own right.

I would say that the Helvetica craze is actually a sign of a growing interest for typography as an end in itself, but it is harder to say if typography as an art form actually has benefited from it. I can only speak for ourselves when I say that when we design the books for our publishing house, "pocky" (this is when we use Helvetica a lot), we work hard on the finer details and try to elevate the typographic standard of the paperback to that of a hard cover edition.

http://www.swedengraphics.com/index_ok.html

RYAN McGINNESS

U.S.A.

Why do you use Helvetica?

I use Helvetica when I don't want the typeface to get in the way of the message. For me, Helvetica has almost become the anti-typeface.

What do you think Helvetica signifies?

Helvetica used to signify power, organization, and authority. Now I don't think Helvetica signifies anything.

Would you agree that there is a renewed interest in Helvetica at the moment? If yes, do you use Helvetica to show allegiance to a certain approach or style or to a certain ideology?

I see a lot of pastiche uses of Helvetica in *faux*-Modernist layouts and pseudo-Swiss compositions. A lot of these approaches are empty of their original political agendas, which is neither here nor there, especially because I can't believe striving for a global mono-culture through a one-size-fits-all typeface is that noble an agenda. Using Helvetica naively can be likened to wearing K-mart-purchased punk clothing with swastikas on it.

When I use Helvetica, it is not to show allegiance to a certain approach, style, or ideology. Rather, I use Helvetica as a tool that will not reflect any approach, style, or ideology. After all, only designers can see Helvetica.

Are you familiar with the original ideology behind the design of such typefaces as Helvetica?

Yes.

As a designer, do you think it is important to be aware of this original ideology?

No, I really don't think it's important or even necessary for designers to be aware of the original ideology, because 99% of the designer's contemporary audience hasn't got a clue, and Helvetica's original ideology is no longer reflected in the face. Helvetica has become as empty a signifier as a peace sign.

What do you think is the reason for this renewed interest in Helvetica?

When the novelty of that nutty Carson style began to fade in the fall of 1997, a lot of designers were looking for something to counter that intuitive approach. Helvetica helps give the appearance of more thoughtful and logical solutions, regardless of whether those solutions really are carefully considered. I don't think there is an interest in Helvetica per se, but there is an interest in blank, default, plain, and straightforward communications.

Do you think that the way Helvetica is used by yourself and others — often very stripped down and restrained, almost default-like — is an easy way out typographically? Could it signal a general disinterest in the finer details and art of typography? Or does it signify something else entirely?

I think you're right about there currently being a general disinterest in typography. Using Helvetica is very easy and helps me avoid having to confront different typefaces. I used to date a lot of different faces, but Helvetica always seemed to be there in the background, and as plain as she may be, she's rock steady.

ANDREW JOHNSTONE

Design Is Kinky
Australia

Why do you use Helvetica?

I guess the main reason is that it's such a nice clean typeface that seems to work well on pretty much any sort of design or layout. The amount of different weights and variations is another major reason. I also think that it is such a familiar font that it's easy to remember and becomes an easy choice. There are literally thousands of fonts out there and to remember them all or to even look through them all would take more time than it's worth. So using Helvetica is an easy way around that, and you can do so with the knowledge that, if used correctly, it will pretty much always suit what you're doing. This is a pretty lazy reason but is definitely one of the reasons I tend to stick with Helvetica.

What do you think Helvetica signifies?

It depends a lot on the individual using it, but I'm not sure that it signifies anything in my own work. I simply like the way it looks and also like the choice you have of so many different variations and weights. That's pretty much the reason I use it. I don't really use it for any significant reason.

Would you agree that there is a renewed interest in Helvetica at the moment? If yes, do you use Helvetica to show allegiance to a certain approach or style or to a certain ideology?

I think Helvetica has always been used quite heavily in the design world and I am not so sure if this has increased lately or not. It may have, but since I don't really take notice of these things, I couldn't say.

Are you familiar with the original ideology behind the design of such typefaces as Helvetica? As a designer, do you think it is important to be aware of this original ideology?

Honestly, no I am not, and no I don't. I think it is important to know how to use a typeface properly but I don't think it is really necessary for a designer to know the history of each individual typeface. Perhaps if you wanted to use it for a major corporate job, such as signage or something like that, it would be good to know, but if all you're doing is placing some text on a personal design,

I think it is pretty irrelevant.

Do you think that the way Helvetica is used by yourself and others — often very stripped down and restrained, almost default-like — is an easy way out typographically? Could it signal a general disinterest in the finer details and art of typography? Or does it signify something else entirely?

I am by no means an expert on typography. Actually, I would go as far as saying that I know almost nothing compared to many people. However, I studied design a good few years ago when type was still seen as an important part of design studies. I have noticed today that this is not the case, and young designers are instead more interested in learning the latest programs and being able to do the new flashy things rather than really being interested in type. Some people say this is bad, others say that it is simply that the times are changing. Who's to say who is correct?

As for how I use Helvetica... In my own case I will admit that I am a pretty lazy designer. If the type is a major part of a piece I am making, which it usually isn't, then I will spend a bit of time on it, but usually the type is secondary to the image and therefore I will not spend all that much time on it. I know the older generation of designers will see this as very lazy, but that's the way I work.

http://www.designiskinky.com/

GEOFF COOK

Base
U.S.A.

Why do you use Helvetica?

We use Helvetica when we're lazy. Or when we've tried a dozen other typefaces on a project. Then we use Helvetica and realize it works better. We always feel sad when this happens.

We also use Helvetica because it's neutral, popular, and bold. For us, Helvetica means "the sans serif type" (in the same way that Times means "the serif type"). That's very nice. We also use Helvetica because a lot of Swiss designers work at Base. They use Helvetica all the time. It's like their natural language, their mother

tongue. They don't think twice about using it. It's funny. It's like it reminds them of home.

What do you think Helvetica signifies?

Helvetica means "a typeface from Switzerland."

Helvetica means "order."

But we also find that when layouts are composed in Helvetica, they say:

— look how clean I am

— look how clear I am

— look how ordered and structured I am

— look how readable I am

— look how modern I am

— I know I'm a bit cold but, you know, it's cool to be cold

Would you agree that there is a renewed interest in Helvetica at the moment? If yes, do you use Helvetica to show allegiance to a certain approach or style or to a certain ideology?

No, not really. Helvetica will always be there and will always be useful in certain cases. It's like butter, flour, or potatoes. They don't taste particularly good on their own, but you always need them at some point when you cook.

Showing allegiance to any style or ideology when we use it? Um... you lost us there.

Are you familiar with the original ideology behind the design of such typefaces as Helvetica? As a designer, do you think it is important to be aware of this original ideology?

No, we're not familiar with its original ideology. But it has certainly something to do with being readable and being modern. And being Swiss. Perhaps the objective was to strive to be the "ultimate" typeface. To solve this "now what type do I use in this project" question once and for all. It's obviously not a "nice" typeface. It has something rather fascist about it. That's why it's always good to use it in a clumsy way or in an inappropriate environment.

What do you think is the reason for this renewed interest in Helvetica?

It's all about cycles. Now it's Helvetica? Perhaps designers were a little tired of these Emigre typefaces. You'll see Helvetica everywhere and then everybody will be tired of it and it'll be over very soon. Don't worry. Akzidenz Grotesk is much nicer anyway. At Base we're currently into handwritten typefaces.

Do you think that the way Helvetica is used by yourself and others —

often very stripped down and restrained, almost default-like — is an easy way out typographically? Could it signal a general disinterest in the finer details and art of typography? Or does it signify something else entirely?

Yes. It is definitely an easy way out. You always feel a bit guilty when you use Helvetica. It means you've lost and Helvetica has won. Sometimes we just hate it for that. But using Helvetica also has one big advantage. It means: "Don't look at the typography. Don't be distracted by the typography and its meaning. Read (hear) the message for itself. Look at the rest; look at the image, look at the photography." Helvetica is so bold and direct. And that's something we really love about it.

http://www.basedesign.com

MICHAEL CINA

WeWorkForThem
U.S.A.

Why do you use Helvetica?

Helvetica (and I use Helvetica Neue, which is drawn extremely well), represents the most basic drawing of the alphabet that one can possibly hope for, although I realize that this is a bit of an overstatement. It is unobtrusive and extremely legible. To me, it represents the most simple form that a typeface can have while keeping a distinctive appearance without being flashy. Faces like Meta just don't read like Helvetica does. Helvetica is easy on the eyes and no letters or their characteristics jump out when reading it in text. To me, it's the lowest common denominator of typefaces. It is the perfect blend of form mixed with legibility. I have often thought about trying to draw the most simple and readable font, and it always comes out looking like Helvetica.

What do you think Helvetica signifies?

I see Helvetica with a hint of nostalgia, while I also see it as very modern and timeless in many ways.

But if you want to use typefaces that are highly legible and have a certain amount of history built in to provide nostalgia, why not use serif type

like Garamond or Palatino? Are you nostalgic for a particular time, like the late 50s when Helvetica was introduced? Or could it have something to do with the fact that designers see other designers use sans serifs in a way that appeals to them and they want to emulate a certain look?

When I say "nostalgia," I think particularly of the Bauhaus and Swiss schools of design. We are very interested in serif faces and we have comped them many times. For some reason, the sans wins because we feel that sans represents a more modern look and feel. This isn't to say that serifs can't be used in a modern format. We particularly like Galliard and Tyfa, but we love typefaces of all forms. Sans serif typefaces, for sure, have a more modern look that we feel best matches today's design æsthetics. We worked on a trademark recently, and were creating serif type, and the client's first reaction was that serifs were too old for the look they were going for.

Would you agree that there is a renewed interest in Helvetica at the moment? If yes, do you use Helvetica to show allegiance to a certain approach or style or to a certain ideology?

Yes, I think that Helvetica has recently been used more. It was used a lot in the 60s and 70s, as most people know. And I think you are seeing it again because of its simplicity. It communicates clearly, and you are seeing a lot of designers going for a more basic approach to design. Helvetica fits that.

I presume you mean there's a more basic approach to "typography." Because if I look at your overall design, it's anything but basic. It's actually quite complex. Beautiful, but complex. And why do you think there is a more basic approach to typography? Is that simply a reaction to the self-expressive use of type in the early 90s, or is there another more profound reason?

I think there is a reaction against the early 90s at work, for sure. To some degree, design reflects what's going on in society, and we all want things to be simple. So we see a revival of people doing very clean and simple typography. But using type in a very basic and simple way holds a greater responsibility; it requires proper typographic knowledge. I think a lot of designers have insufficient knowledge of type or typography and it often shows.

Are you familiar with the original ideology behind the design of such typefaces as Helvetica? As a designer, do you think it is important to be aware of this original ideology?

I admit I am ignorant about any ideology behind fonts such as Helvetica. I do know groups such as the Bauhaus loved sans serif typefaces for their simple look and form. The sans was a new and exciting form back then, I am sure. I know that Akzidenz Grotesk was designed in the late 1800s, and has a look and feel similar to that of Helvetica. Max Miedinger obviously took a good look at Akzidenz.

Do you think that the way sans serifs are used by yourself and others — often very stripped down and restrained, almost default-like — is an easy way out typographically? Does it in any way signal a general disinterest in the finer details and art of typography? Or does it signify something else entirely?

I have a great love for typography, and to say that using Helvetica/Neue Haas Grotesk comes from a disinterest in the finer details of the art of typography is just a slap in the face to design. This would negate a major part of design work created throughout history.

Regarding current work, I would also disagree. Using one typeface in a simple way cannot be equated with having a disinterest in typography. On the other hand, I do think there's a greater disinterest in typefaces nowadays, which may have something to do with design education. I would guess many designers couldn't tell the difference between Akzidenz Grotesk, Arial, or Helvetica.

http://www.weworkforthem.com/

JORDAN CRANE

U.S.A.

Why do you use Helvetica?

I use Helvetica in my own work for a number of reasons. One, it is very legible. Two, I want a typeface that is almost void of stylization. Not to say that Helvetica isn't a highly stylized typeface, but in comparison to other typefaces, it is reserved in appearance. It has that "it is what it is" characteristic that I want. It is modern without being a showoff. To me, it is a vehicle to deliver ideas and thoughts,

and other typefaces would just add a degree of complexity in design that I'm not looking for.

What do you think Helvetica signifies?

Today, I think Helvetica signifies a degree of modernity with a nod to history. But more importantly, and above all else, it signifies a commitment to clarity in delivery.

Would you agree that there is a renewed interest in Helvetica at the moment? If yes, do you use Helvetica to show allegiance to a certain approach or style or to a certain ideology?

I guess so. I want the ideas in my own work to visually communicate in the most direct, easily understood way possible, and there are certain design movements that put an emphasis on that, but I have no allegiance to those movements.

Are you familiar with the original ideology behind the design of such typefaces as Helvetica? As a designer, do you think it is important to be aware of this original ideology?

Yes I'm aware of its ideology, history, and usage. For me, it is somewhat important to know its history. Could I know more? Yes. But I don't think it's important for everyone to know. For me, it comes down to your own personal desire to learn the history and to apply that knowledge in whatever way you want. For instance, I know some really great cooks, some who know about the history and historical context of what they are preparing. And I know some cooks who couldn't care less about the political and social history of the chili pepper. But both make great food that I'm willing to eat.

Ideologies change and merge with other ideologies over time, but the products of those ideas remain there to use, recycle, and change as people see fit. No one questions it now when you walk into a room with an Eames chair on a Persian carpet from the 1800s.

What do you think is the reason for this renewed interest in Helvetica?

It might have to do with the fact that it is loaded onto every computer sold today. But it also has to do with the fact that we are dealing with so much technology that moves so fast and concepts that are so mind-boggling now that a legible typeface like Helvetica helps us organize visually and mentally all the images and ideas that we come across from every corner of the world everyday.

Do you think that the way Helvetica is used by yourself and others — often very stripped down and restrained, almost default-like — is an easy

way out typographically? Could it signal a general disinterest in the finer details and art of typography? Or does it signify something else entirely?

Yes and no. I can't speak for others, but I consciously use it for that default, stripped-down like appearance in my own personal work. As for taking an easy way out typographically, it all depends on the reason why it is being used and what it is being used for. For some, though, I feel there is generally a lack of understanding of design in general and a lack of understanding of how typography relates to the overall completed designed piece.

I think one reason why there might be a perceived lack of interest in typography is that now more than, say, twenty years ago, anyone can call themselves a graphic designer, which is good and bad. Good, because you get people in design who maybe couldn't afford to go to school. And good, because now if you have a computer, you can share your creativity with everyone in world. Bad, in that you might lose out in that design bid to a fourteen year old kid from suburban Chicago, who just underbid you. Unfortunately, for some, valued subjects like typography are being pushed to the side because of the rush to just keep making work and to keep up with technology. I think it signifies a change in design, a change that is inevitably coming. Design is becoming less structured and more rigid all at the same time, defining the culture and being defined by culture. Typography will always be there. It will just undergo change.

http://www.jordancrane.com/

CARLOS SEGURA

T-26
U.S.A.

Why do you use Helvetica?

I use Helvetica (and fonts like it — Interstate by Font Bureau being one of my favorites) because it seems to best capture the sense of clarity and cleanliness prevalent in our current visual landscape. From architecture to furnishings to design, there seems to

be a desire for simplicity that this type of typography feels at home with.

What do you think Helvetica signifies?

I don't know that it signifies anything specific for me. It's more of a state-of-mind that it brings to the table, allowing the hero to be something other than the font used.

Would you agree that there is a renewed interest in Helvetica at the moment?

Yes.

Do you use Helvetica to show allegiance to a certain approach or style or to a certain ideology?

No.

Are you familiar with the original ideology behind the design of such typefaces as Helvetica?

No.

As a designer, do you think it is important to be aware of this original ideology?

Perhaps, but I don't approach work that way. Primarily because I believe the executions should be appropriate to the strategy, and should speak intelligently to the consumer, one who will not have the luxury of knowing my thoughts, or the theories of any font I may use.

But these "strategies" obviously change over time. For instance, a few years ago we saw a lot of "grunge" type (for lack of a better word). Do designers forge these changes, or do they simply affirm them?

A few lead, the rest follow.

What do you think is the reason for this renewed interest in Helvetica?

I touched on this a bit above, But I do think some of it is based on the prevalent "copycat" approach in this design business.

But if there is a current "desire for simplicity" within the culture and "appropriate" ways to communicate, isn't it unfair to talk about "copycat" approaches? Isn't it design's business to hook into whatever is currently hip and speak in the appropriate visual language in order to communicate most effectively?

Yes, but there is a difference between copying an effect and doing it because it is appropriate.

Do you think that the way Helvetica is used by yourself and others — often very stripped down and restrained, almost default-like — is an easy way out typographically?

Maybe by others, but if we use it, it's because we want to, or think it is the right thing to do.

Does it in any way signal a general disinterest in the finer details and art of typography?

Not at all. That would be like saying that Helvetica is an execution not as worthy as anything else. I think there are some very beautiful ways of using this font, and others like it.

http://www.t26.com/changeyourface.php

MICHAEL BIERUT

Pentagram
U.S.A.

Michael handily ignored our pesky questions and instead submitted the following short essay.

I became infatuated with graphic design as a teenager in suburban Cleveland in the early seventies. I was always "good at art" but graphic design seemed to have a magical quality to me that art did not. Part of this had to do with what I perceived as the authority that designed objects seemed to signal. I was obsessed with designing posters for my high school plays that looked as "real" as movie posters, or logos for my friend's garage band that looked as "real" as l.p. covers. Typeset — as opposed to hand drawn — type was definitely an element in this patina of legitimacy. At the age of 14 in Parma, Ohio, I hadn't the faintest idea of how one would go about getting type set, and so like a lot of us, I became very good at tracing. Then one day my dad happened to visit a trade show where they were giving away free samples of a hot new product, dry transfer lettering. He brought me home a single sheet of Chartpak 36 pt. Helvetica Medium. To this day, that typeface at that size and weight has the same effect on me as hearing "Maggie May" by Rod Stewart. It was what I was yearning for: Magical Instant Real Graphic Design in a Can. Take any word, set it nice and tight in Helvetica Medium, and boom! Immediate authority.

When I took my first job a few years later working for Massimo

Vignelli, I learned that this immature enthusiasm was not that far off the professional view of the typeface that had reigned for the previous fifteen years or so. Clearly, there was a moment when the default solution for any graphic design challenge was Helvetica. Take any old company name — Memorex, Knoll, American Airlines — Boom, boom, boom. It must have looked so great, so thrillingly bracing, so self-evident, when it was all brand new. Of course, this fell directly in line with a Modernist ideology that sought reduction, neutrality, and objectivity at all costs. I remember Massimo (Vignelli) talking about Helvetica being the typeface "we had all been waiting for". (In fact, the signs for the New York subway were made with the charmingly named Standard Medium because Helvetica wasn't available in the U.S., or at least not in the sign shops of the Metropolitan Transit Authority.) There was this sense that a gradual process of refinement had led through Akzidenz Grotesk and Standard Medium and all, finally ending with this one perfectly refined typeface.

Now, by 1980 when I started with Massimo, the reaction had already set in. Helvetica was so overused that it had lost its power: Setting a company name in Helvetica made it look not authoritative but generic. (Even Massimo's letterhead was in Century Expanded.) So I actually used Helvetica very rarely for most of my professional life. Yet the yearning for that kind of bracing clarity hasn't ever completely gone away. One of the most interesting aspects of the post-MacIntosh era has been profusion of typefaces that might be "the new Helvetica," fonts that would have Helvetica's original clarity but not debasement through overuse. So we've had Rotis, Meta, Interstate, Nobel, Avenir, Gotham.

I agree that these days there is a renewed interest in Helvetica. It probably began half as a desire to wipe the board clean after the excesses of the early to mid-nineties, and half as an attempt to comment ironically on the authoritarian tone of the first wave of Corporate Helvetica in the late sixties/early seventies. Now, of course, most people just think it's a cool new style and it comes to them unburdened with history, ideology, irony, or anything else. It just looks cool. (I can't really criticize, since that's pretty much what I thought back in the early seventies.)

Finally, I think there's no such thing as a default choice of typeface. Whether you're imitating Josef Müller-Brockmann, Massimo

Vignelli, Mark Farrow, or Experimental Jetset, or just using it because it loads fast and looks clean, it's a choice. I hardly ever do it myself these days, but when I do, there's nothing else like it.

http://www.pentagram.com/start.htm

42

From a Concerned Citizen at Cranbrook

by Joshua Ray Stephens

GRAPHIC DESIGN IS SUFFERING from a dearth of critical thought and a lack of interest in furthering a dialogue through writing and analysis. Maybe this should not be blamed on graphic designers, but on the sorry state of affairs in academia and on the intellectual cognoscenti upon whom graphic designers rely as their source of ideas.

But is graphic design, and more importantly, intellectual culture in general, really afflicted by a lack of new or fresh ideas? Or is it just a lack of a convenient handle or moniker? Without a catchy title like "Modernism" or "Post-modernism" or "Deconstruction" or "Phenomenology," how can a broad swath of disparate ideas be disseminated, assimilated, and ultimately destroyed by a mass audience?

What we need is a name. A solution. An answer. No—better yet—a question. Of course. The question. The answer is the question. So what is the question? Who knows? Where are we headed? Why? Please feel free to dispense with this line of reasoning.

I have the long-awaited response to Post-modernism. This is what we have been breathlessly waiting for. All of you gut-less *faux*-intellectuals decrying the death of theory, all of you polished professionals proselytizing a new manifesto for growth or social and environmental morality and "responsi-bility," all of you polished professionals hypocritically hypothesizing style as so much bad wind, rest easy. The new New Wave is here: *Antidisestablishmentarianism.* That's right. We heard of it in high school English and passed it off as an anomaly, but there it is. A punk neo-con. A hardcore dogma.

How does it work? It embraces what Mr. Keedy seems to think is a conceptual flaw. The arbitrary rules of eternal forms that Modernism so thoroughly and rigorously explored and utilized are our starting point. But we take them and make them so arbitrary it hurts.

Antidisestablishmentarianism takes the basic tenets of Lars von Trier's DOGME 95, applies it to graphic design, and follows it even more dogmatically than DOGME. No artificial ornamentation. No excess material waste. Univers is the new Helvetica. Univers has everything we need. Frutiger came, and before the end of the world he will come again. We will hasten his arrival. Why do we need to understand and use a grid, or a system, when we can understand the concept of a grid or system and easily fake their existence? *Antidisestablishmentarianism* takes academia's current spineless fear of irrelevance and strives for an irrelevance taken to such an extreme that it folds back upon itself like that inimitable, inevitable, infinite dragon and eats itself— simultaneously becoming so relevant it hurts. *Antidisestablishmentarianism* creates a design idiom that is steeped in the minute esotericism of the most esoteric design and produces a design for designers even designers cannot understand. Effectively concocting the most potent culture bomb to explode onto the intellectual scene since Deconstruction. And more modern than Modernism ever dreamed; even at Corbusier's or Mies's most modern heights of modernistic ecstasy. Helvetica is played. Time for something new. Up with Univers. *Antidisestablishmentarianism*. We've got a name. We've got a movement. The tortured intellectual elite who are too smart to find a way to be passionate and not smart enough to find a way to fake it can finally rest easy. *Antidisestablishmentarianism* is a tuxedo jacket with tails long enough for the whole world to ride on for at least another quarter century—more likely forever.

But how can it last forever? Anyone at all familiar with Hegelian dialectic knows that the antithesis will be spiraling back around shortly. And with the shorter and exponentially shorter dialectic life span of all movements throughout history—leading up to the last ten years or so in which we have witnessed the dispersal of trends to the point of absence—*Antidisestablishmentarianism* can't last long. It's already over. Woe is the state of graphic design. Woe is the state of philosophy. Woe is the state of literature. Woe is the state of culture. For a hot minute, a blazing moment, graphic design was in the perfect position to swoop down and become the new Rome. A cultural Roman empire. Resources consolidated, responsibilities meted out, a vast web of networking capabilities utilized. *Antidisestablishmentarianism* was going to take over. It was going to be here to stay. Fulfilling the promises of bygone and long forgotten isms in a gloriously transcendent way. But its simple complexity was its own undoing. It was inevitable. Hubris proved to be too much. As its imagined future successes went to the heads of its soon-to-be practitioners, it pre-degenerated into abject expressionism. How could it not?

Maybe there is an answer. Better yet: new questions. A deeper inquiry is needed. There seems to be something pertinent we have forgotten. An aborted fetus that had the promise of a rewarding life. A promise ignored by a selfish mother and father. Why did we abandon Post-modernism so quickly? Maybe it really was the end of philosophy? The death of the author. Maybe it nailed the coffin shut on the author and subsequently occluded any chance at a true movement in the arts and culture industries forever more. No. I cannot believe it.

What we need is a return to Post-modernism. A Post-post-modernism. A *Poshlost-modernism* if you will. If Post-modernism perverted and subverted kitsch in a collage of deconstructed, authorless pastiche, our new *Poshlost-modernism*

will exploit a thin veil of glossy immaterial materialism
to engender a fantasy, the very falsity of which will enrich
its paucity of meaning. A paradigm of paradox. *Poshlost-modernism* will be misunderstood at first because of its superficial resemblance to art and its titular resemblance to
Modernism. It is, however, the most promising opportunity.
Post-modern design was retreated from all too quickly. It was
not given the necessary crystallization period for maturation.
There is still so much to be mined. It is not as stale as Andrew
Blauvelt would have us believe. It requires further vertical
exploration. *Poshlost-modernism* is it. Neo-conservatives and
fundamentalists will shy away and decry it because of its
seeming pantheism; an eclecticism that the old guard believes
leads to an anything goes attitude and subsequently to
homogenization. It is interesting that a Modernism that fears
this eclecticism because of where it could possibly lead is the
same Modernism that somehow misses the homogenized ending that is necessarily caused by the "universal" and "eternal"
æsthetic it proposes. Truly, style is equivalent to flatulence.
Poshlost-modernism ushers in the return of the caustic biomorph in order to attain its logical transcendent conclusion;
the evolution of the crystallized fusion of incongruity.
Systems converge and merge in a cataclysmic *faux*-apocalypse; hastening the arrival of the second coming of David
Carson. And with it, the faux-finish facade masking the vacuous regions of *Poshlost-modernism* leading to the blinding
light of chaos: transcendence. The last vestiges of Modernism
will kick and scream clawing at straws, but will ultimately be
vanquished. *Poshlost-modernism* rises from the ashes of Postmodernism and subverts the culture machine from the inside.
The dead author's ghost has vanquished the modern hero's
lack of soul.

Anyone with a hint of vision can see the impasse *Poshlost-modernism* is rushing towards on the not-so-distant horizon.

Anyone who does not should buy a pair of binoculars. The initial amounts of incredible energy will not be sustained by its leaders, and its young protégés will unwittingly miss the point to ultimately "lapse into a convenient formalism" (Andrew Blauvelt) or become frustrated and cynical as they strike out in their own pre-paved direction. Then, expectedly, the ever-churning culture machine assimilates *Poshlost-modernism*'s most digestible ideas and discards its most radical ones, leaving the surface impression intact but effectively obliterating its insides. Left with nothing but a sludge-filled husk, the last practitioners will slither away, disappearing into the unknown wilderness of passed cultural trends. Which leaves one with the ever unspoken and blatantly obscure truth.

The truth lies somewhere in between. Outside really, or above. Interesting that two such contended and supposedly opposing schools of thought ultimately lead to the same conclusions. As it seems opposites have a tendency to. Modernism in its claims to objectivity and absolutes with its roots in Aristotelian or Socratic thought leads ultimately to homogenization of form and ruthless formalism in the name of function. Post-modernism in its claims of subjectivity with roots in Sophist rhetoric and Eastern circularity leads ultimately to homogenization of function and ruthless functionalism in the name of form. The key, of course, being that both, as grand and general trends, lead to homogenization and therefore a perpetuation of Western hegemonic tendencies towards globalization. The point being that "schools" and "trends" and "isms" have never lead anywhere but to groups. Groups mainly consist of followers. Followers do not chart their own paths. And in a field of trend watchers who are paid precisely for their ability to spot superficial trends and exploit them, why would anyone expect there to be much more than superficial inquiry in the field? To be frank,

I am impressed by the amount of critical thought there actually is in graphic design. Which is not saying much. As always, the amount of real quality work being done in graphic design, and any field for that matter, is done by staunch individuals who have no real connection to any group, school of thought, or trend, except in the bookstore aisles where they have to be categorized in order to be marketed.

The pitiful state of design/art/thought/writing/philosophy in our increasingly homogenized culture is of utmost importance. I do truly believe that the percentages of quality contributions to humanity, with minor fluctuations here and there, have essentially remained the same throughout history. To my mind the percentages break down something like this: 100% of production can be divided like so: 50% absolutely worthless drivel, 40% otherwise worthless but digestibly entertaining drivel, 3-5% relatively intelligent, relatively worthwhile creation that falls into certain types of categories (e.g., it may be a good character-driven story but not really great structurally, or conceptually interesting but not formally, or vice versa, etc.), 3-5% self-consciously intelligent Poshlost and therefore pompous and ultimately counterproductive creation, 0-4% (4% probably never occurs) complex, difficult, multilayered, enriching, and rewarding creation.

The problem at this incredible moment in history is not the percentages of production but the fact so much is being produced with profit as the bottom line and quantity as the sole barometer, that those in charge of production are less and less willing to take a chance on something complex and difficult, something of quality. Therefore it is increasingly difficult to find, buried beneath megatons of well marketed slush, something of true value. For instance: less than 100 years ago there were publishers willing to not only publish but truly support such difficult and innovative artists as James Joyce or Vladimir Nabokov in a way that not only dis-

seminated their work to a mass audience but made them international icons. And yet, since about the late sixties or early seventies, the best our mainstream literature has had to offer is Stephen King or John Grisham. Now that is just sick. Really. It's unfortunate that more people do not seem to find this truly disturbing and problematic.

Bleaker in terms of graphic design is the fact that in its short history it has cultivated an even smaller percentage of truly important work. In terms of art, America's design god, Paul Rand, is not even a minor hero, much less a regular on the peaks of Mt. Olympus. And when I speak of art, I speak of it in terms of what I consider to be its broad sense; not work that is meant to be exhibited in a gallery but the Art that occurs in any creative medium. Whether that be literature, painting, sculpture, graphic design, or basket weaving. The most important obstacle for a designer to overcome in order to create something that has true artistic merit but that is still graphic design, is precisely that utility is the bottom line, that which separates design from art or religion (to paraphrase Mr. Keedy). Utility is fundamentally opposed to the challenging complexity that should necessarily be involved in a work of art. But does it have to be? Maybe not. Challenging art by its very nature serves one of the highest purposes mankind can know: access to mystery. Life. It is life-giving and life-sustaining. And how can this be anything but useful? Maybe the reason that so few designers have entered or even dipped a naked timid toe into the vast ocean of art is the necessary risk involved in doing so. In order to make something truly meaningful there has to be a sense of commitment. There must be something at stake. Something truly human; not simply a job. Which is not to imply that a job is not important, but it is not psychologically charged in the way that an emotionally vulnerable art should be. The few people that have attempted such feats in anything resembling a sustained

manner have enriched the design field immensely, whether anyone is willing to accept it or not. Elliott Earls and Ed Fella, for instance, have both affected the design world and more importantly the world at large in ways that we have still yet to find a method of measuring. Immeasurability is often taken for a weakness, especially to those of us who need to see a score sheet at the end of the game. But true art, life-giving art, transcendental art, important art is by its very nature unquantifiable. Because as with poetry, or language for that matter, its utility is to lend, however briefly, light to the ineffable mysteries of the universe. Art is its own utility. Graphic design can be art. It's just unfortunate that it so rarely is.

The field is, at the moment, in a state of *Ambivalism.* We love to make things look good, but we hate to feel guilty for the perpetuation of rampant materialism. We love to postulate a responsible and relevant design, but we hate to be faced with the prospects of practicing it. We love to wax philosophical in one sentence blurbs, but we hate to be asked to actually think and articulate. Graphic design is in the unique position that all ubiquitous institutions (technology, government, propaganda, ideology) find themselves. It is simultaneously everywhere and invisible. It is such a vital part of everyday existence as to be indispensable, and yet hardly anyone outside of it even knows what it is. This position is one that could be explored and exploited to a degree that seems to not even have been attempted by most. It is simultaneously the medium's strongest and weakest link. It affords practitioners the freedom of invisibility that could provide them with an incredible power; it also places them in a self-referential loop that more often than not renders their invisibility ineffectual. Yes, graphic design can be art. It's just unfortunate that it so rarely is.

Joshua Ray Stephens earned his BFA in graphic design at University of Georgia, flew to Italy the day of his graduation to spend a year at Fabrica, then moved to Detroit to earn his MFA at Cranbrook Academy of Art, and is now itinerant.

52

DEFAULT SYSTEMS DESIGN

*A discussion
with Rob Giampietro
about guilt and loss
in graphic design.*

When writer/designer Rob Giampietro approached me a few months back with the idea of writing an article about graphic design in the 90s, he brought up an unrelated topic during our conversation that I found intriguing: he mentioned the term "Default Systems Design." He said it was the topic for another article he had been working on for the past few months.

It's curious how certain ideas reach critical mass. In *Emigre* #64 a number of contributors, independent of each other, noted the emergence of a new kind of graphic design that seems to rely heavily on the use of systems and defaults. Just when you think graphic design has very little new to offer, something's taking root. Reprinted here is how we arrived at the topic, as well as edited segments of the rest of the conversation.

Rudy VanderLans: If the level of graphic design criticism is at all a gauge for the state of design today, then design is as good as dead. We saw a surge of critical writing within design in the early 90s. To some degree this had to do with the times; there was a significant change in technology with the introduction of the Macintosh computer, which coincided with (or caused?) the bankruptcy of the Swiss International Style. But, after many debates, everybody settled down and went about their business. I guess it's difficult to forge a revolution (for lack of a better word), every ten years or so, or maintain a critical opposition indefinitely.

Rob Giampietro: While I understand your frustration, I would say such times of boredom and stagnation are times in which critical opposition is most crucial. It's easy to be righteous when everyone thinks you're right. It's much harder when they've changed their minds.

And that's what you think has happened? Designers have become more conservative again, more in line with the *status quo*? Which is not surprising, of course. In times of economic and political uncertainty, when the future looks bleak, there seems to be a tendency to look back, to choose

safe solutions. Within graphic design we've seen an upswing in retro themes, nostalgia, and the return of what looks like the Swiss International Style.

The look of graphic design today is evidence of the pendulum swing back to more conservative and fiscal-minded times. It is a counter-revolution of sorts, and its assumptions are troubling, and real, and on MTV, and in *Emigre* itself.

Why are its assumptions troubling?

Because this kind of work self-consciously positions design as stupid and trivial and says that documents of importance needn't rely on design to shape them. Default Systems are machines for design creation, and they represent design publicly as an "automatic" art form, offering a release from the breathless pace at which design now runs, as clients ask for more, quicker, now. Default Systems are a number of trends present in current graphic design that exploit computer presets in an industry-wide fashion. They are a quasi-simplistic rule-set, often cribbing elements from the International Style in a kind of glossy pastiche, a cult of sameness driven by the laziness and comfort of the technology that enabled *Emigre*'s rise, the Macintosh.

Do you think this was perhaps an obvious reaction to the hyperpersonal, customized messages of early 90s design?

Yes, in some part. What's interesting is how much Default Systems owe to early 90s design. The rejection of all systems by these "hyperpersonal" designers was itself systematic. Fussiness for its own sake in the early 90s is the same as reductivism for its own sake in the late 90s and today. designers from Cranbrook and those mentioned in Steven Heller's "Cult of the Ugly" article in *Eye* magazine (No.9, Volume 3, 1993) were nothing if not brash and dogmatic. Their ideal of "beauty" was nothing if not relative. Their models, like those of designers using Default Systems, were found in "low" forms, and the ceaseless glorification of these forms was as self-indulgent then as it is now. The stylistic methods of Default Systems design arose from the methods of Ugly design and they are tactically one and the same. Both are based on different kinds of proliferation and limitation. The distinction between the two is largely formal, which is of interest to designers, but their social observations are largely similar, which is of interest to critics.

This raises a few questions. First, what do you mean by "Both are based

on different kinds of proliferation and limitation"? Secondly, how are the social observations of "Ugly" design and "Default Systems" design similar? What is it that they have in common?

These two questions are related. The use of terms like "proliferation" and "limitation" is self-conscious on my part. These terms sound as if they come from a Marxist critique rather than a design discussion. I'm not trying to make this discussion overly academic; rather, I am trying to provide design critics with a model for positioning design within a broader social context, which doesn't always happen. The most interesting designs are critiques of the conditions of their own making, and Marxist language is useful for discussing the means of production and consumption because it was developed for that purpose.

That doesn't answer my question, though.

Right. However, if, as I just said, the most interesting designs are critiques of the conditions of their own making, then both Ugly design and Default Systems design qualify as "most interesting." Both exploit certain opportunities presented by the computer as a tool while suppressing other opportunities. Some tactics are allowed to proliferate while others are deliberately limited. For example, the computer is a tool that allows for incredible cutomization. Typefaces — even individual letterforms — can be altered to a user's tastes. Ugly designers let this kind of customization run self-consciously amok. This was done in the name of a kind of democracy (every user is different), as well as a kind of authenticity (ugliness is pure and therefore true). What's interesting is that although Default Systems design looks so different from Ugly design, its interests are still tied to being authentic and being democratic. Default Systems design claims, "This is how the computer works with minimal intervention." It also claims, "By keeping the designer from intervening, this design language is made available to all." So Default Systems look new, but they arise from the social concerns of the old. I'd call this "Hegelian," but I wouldn't want to make this discussion any more academic...

I suspect that Default Systems arose from a kind of shame that plagued designers after accusations that their work had become overly self-indulgent in the face of the limitless possibilities of desktop publishing and a certain version of Post-modernity. This notion finds its first theoretical articulation in Summer 1995,

when Dutch critic Carel Kuitenbrouwer wrote in *Eye* of "The New Sobriety" creeping into work of young Dutch designers at that time.

Can you describe some of the features and characteristics of this type of Default Systems design?

Defaults, as we both know, are preordained settings found in common design programs such as Quark, Photoshop, and Illustrator that a user (or designer) must manually override. Thus, in Quark, all text boxes have a one point text inset unless one enters the default settings and changes this. Put simply, defaults automate certain aspects of the design process.

Default typefaces in contemporary design include all Macintosh System Fonts: Arial, Chicago, Courier, Times New Roman, Verdana, Wingdings, etc. Hallmark faces of the International Style that are seen as "uninflected" are also in this category: Helvetica, Akzidenz Grotesk, Grotesque, Univers, etc. Although the latter typefaces are far from meaningless, their original context is as neutral communicators, and this position is simultaneously supported and undermined by Default Systems design.

Defaults also appear in terms of scale. Sameness of size downplays hierarchy and typographic intervention, forcing the reader to form his or her own hierarchical judgements. Default designers argue that this emphasizes reading as opposed to looking, which makes the audience more active, more embodied.

Default placements include centrality as a kind of bluntness and bleeds as a kind of eradication of layout. The center is a default position. One "drops" something in the center; one "places" something off-center. Asymmetric placement is embodied; central placement is disembodied. To bleed a photograph is to remove the page edge as a frame and emphasize the photograph itself. Placements (or non-placements) such as these allow images and texts to function as such. They are expected. Computer templates and formats that employ Modernist grid aesthetics are also included here.

Default colors are black and white, the additive primaries (RGB) and the subtractive primaries (CMYK). Default elements include all preexisting borders, blends, icons, filters, etc. Default sizes are 8, 10, 12, 18, 24 pt. in type, standard sheet sizes for American designers, ISO sizes for Europeans, etc. With standardization, it's argued, comes compatibility. Objects (particularly printed objects)

are reproduced 1:1, and images and documents are shown with min-
imal manipulation.

Who stands out for you as Default Systems designers?

The Experimental Jetset and issue #37 of *Emigre* that they
designed. To publish their work in *Emigre* served to direct the
attention of others to this undercurrent in design, but to mistake
their work for anything more than a saccharinely ironic version of
the International Style (shaken, not stirred) is to give it a kind of
seriousness that their name itself eschews. Set entirely in Helvetica
and using only process colors, standard sizes, and arrangements,
the art direction of that issue is the epitome of "default." The tone
of its essays is jargony and somewhat academic, and the anti-
design of the issue provides them with a "serious" backdrop from
which to make their points. Included is an archive of data storage
formats that have now fallen into disuse, arranged according to
their forms. In the center, bracketing the product catalog,
Experimental Jetset sets up a bland joke: "Q: How many Emigre
products does it take to change a light bulb?" After leafing through
17 pages of products, the reader finds the punch line: "A: Never
enough." The joke falls hopelessly flat, humorless. Other variants
of the "light bulb" joke are repeated throughout the issue and are
presented in ceaseless repetition, like lines of computer code. All
are equally disjointed, equally unfunny. Though the joke is a format,
the humanity of the joke format has been drained. It, too, is a lost
format in need of preservation. Its unfunniness here manipulates
us into feeling a kind of consumerist guilt over desiring the Emigre
products within the bounds of its setup and punch line.

Daniel Eatock's "A Feature Article without Content," also comes
to mind. The piece mocks a portfolio magazine feature article,
demonstrating that expected placement is itself a kind of content.

Another example of Default System design is Issue #7 of *Re-*,
dubbed *Re-*View. It is a self-described "review of a magazine and
its formats": cover, contents, review, short story, agenda, fashion,
interview, and letters. *Re-*View aims to expose the expected and
renders it available to all. The magazine itself has no content: it is
an engine for content. "With texts to be written, not to be read, and
pictures meant to be taken, not to be seen," it is prescriptive and
programmatic while it is descriptive and programmed. Rather than
following the traditional route of content leading design, here

design leads content because the content is an admission of design's role in generating meaning within the context of a popular magazine. Tactics such as art direction are removed from their everyday associations, and presented in a tone that may be mocking, gravely serious, or both. *Re*-View'"s Art Director — capital "A," capital "D" — is eerily similar to a Conceptual Artist — capital "C," capital "A" — a "brain in a jar," generating visual ideas via programs that are meant to be executed by others. This elevates design while dehumanizing it.

You lost me here. How do you both elevate design and dehumanize it?

The linking of design and Conceptual Art is an attempt to elevate design to the "High Art" level of Conceptual Art. There is a difference between "making" and "generating." By saying the role of the designer is to "make" an object, you are saying one thing; by saying the role of the designer is to "generate" a program by which objects can be made by others, you are saying something else. You've elevated what design produces — ideas, not things — but you've dehumanized it by taking the maker out of the equation and substituting him or her with a program. This is a natural leap for design that's interested in the role the computer plays in the production process, because, at some point, the program is what's making the design. But there is a spectrum, certainly. Design that veers closer to Conceptual Art than Computer Science strikes me as being less dehumanized. I may be oversimplifying, however.

While I understand how you have come to use the term "Default Systems Design," I can imagine that designers would have a problem calling their design methods "default." The term has many negative connotations.

In most contexts, "to default" is to fail. To be "in default" on a loan is not to pay it; to "default" in court is not to appear; to win "by default" is to win because the other team did not play.

The only arena in which the definition of "default" is not entirely negative is in Computer Science, where a default is "a particular setting or variable that is assigned automatically by an operating system and remains in effect unless canceled or overridden by the operator." Defaults, at least in terms of computers, are the status quo. Theirs are not the failure to do what's promised but exactly the opposite. Theirs are a promise kept in lieu of an "operator's" (or designer's) intervention. To view a computer through its default settings is to view it as it's been programmed to view itself, even

to give it a kind of authority. Naturally, "a default" is produced by systemic thinking — the definition mentions "operating systems" specifically — and "defaults," taken cumulatively, could be defined as the system by which the machine operates when no one is actively operating it. The system makes assumptions that, unchallenged, become truths.

The use of Default Systems is not exactly a new phenomenon. It's been a known process for generating work within the world of art and literature. It seems graphic design, again, is coming to the scene late.

Well, yes and no. Design punishes itself for not being "on trend" too often and to no end. To do so is to be obsessed with style (which is a shallow effort) or to be obsessed with making design the same as art (which is a pointless effort). Anyone would be hard-pressed to identify a governing principle of a new æsthetic movement that wasn't presaged in some form by a prior movement, especially if you include any genre you want. That said, defaults have been used to create art for a long time. In writing, the work of OuLiPo (*Ouvroir Littérature Potentielle*, "Workshop of Potential Literature") comes to mind. Oulipian poetics ascribes a Default System accommodating a series of constraints and then challenges the author to create a product from those constraints. Oulipian poetics are both emulative and emergent. Their constraints arise from mimicking other constraints, but they still manage to be original and meaningful. The texts of OuLiPo are built both by humans and by the systems that humans build.

In the realm of visual art, 60s Conceptualists like Sol LeWitt are helpful in identifying the underpinnings of "default" working procedures because of their twin interests in failure and systems. Many of these artists use strikingly similar working methods, harnessing non-intervention to generate solutions.

Non-intervention is also significant in contemporary film. Gus Van Sandt's film *Gerry* and his recent Palme d'Or winning *Elephant* are based on site-specific improvisation and camerawork. His films are informed by those of Dogme 95 (which arose from the same countries as "The New Sobriety"), and Dogme 95, in turn, is informed by the French New Wave.

In the hands of graphic designers, to what degree are these Default Systems a sort of critique of design?

In the end, the most potent critiques offered by designers using

Default Systems seem to be linked to guilt and loss. Default Systems, and the formats that they include, comment not just on the mechanics of systems but on systemic thinking in general, and on the new life of man in the networked Global Village. The computer has changed design, but it has also changed our process of thinking and making. Formats and systems govern everything from our weaponry systems to our guidelines for citizenship.

Is that a critique or an affirmation of our current situation.

That's the question. In the face of eroding history, vanishing citizenship, bulging landfills, and sprawling consumerism, what is the critique that Default Systems offer? Are they resistant, complicit, or both? Are their strategies effective or cliched? The answers to these questions will not come from the designers themselves, nor should they. They will come from the critics and from the critical language they derive. To render their forms and tactics available is to open them up for discussion. This discussion is a powerful first step. As design's visual codes become more widely understood, they become more pliable to the designers who employ them. As the assumptions of systemic thinking become popularized, societies may choose more actively to absorb or combat them. Design will play a role in this selection process.

How come so little has been written or said about the use of these Default Systems, which we both acknowledge are widespread?

Because Default Systems are deliberately invisible. To articulate them and the conditions that enable them is an important first step in the critical process. To evaluate their message is an important second step, and this has not been done. The lack of this evaluative mechanism betrays a snag in the fabric of design production with regard to its criticism. The language of criticism must employ its own forms and tactical instruments. Design is still in need of an external critical language, rigorously defined. The development of this language will almost certainly alter the climate and context in which designs are made both now and in the future. The problem is not that Default Systems are bad and haven't been opposed. The problem is that not even designers really understand what they mean. And that problem — along with the irresponsibility that it suggests — is far worse.

Rob Giampietro is a designer and a faculty member at Parsons School of Design in New York City.

62

THE FOLLOWING FOUR ESSAYS were written in direct response to *Emigre* #64. Due to the length and form of each essay they were published separately from THE READERS RESPOND section.

Young Pups Old Pops

by Armin Vit

READING *Emigre* 64, "Rant," felt like getting kicked in the groin.
The blow was deliberate and yes, quite low, right where it would
hurt the most, and with enough time to make a quick run for it.
Fast and furious. But like any good kick in the groin, the pain wears
off, the sperm count goes back to normal and one is able to go on
with life until the next jolt.

I also felt like I was being ganged up on by cranky old designers
(not my words) and had nothing to defend myself with. For a
moment I even thought that I deserved such beating, that I was
and am, part of the "problem." Let me explain: In the mid 90s I
was going through my undergraduate studies in graphic design in
Mexico—far from a graphic design Mecca—during the "golden age"
of design criticism, exploration, and experimentation, but nobody
had the decency to point that out. I had absolutely no clue who was
doing what or why. Not once, in four years, was a contemporary
designer mentioned in the classroom. I'm not kidding. We did study
the Renaissance's chiaroscuro like nobody's business.

In '99 I headed to the U.S.—I had obviously missed the party –
to work for an Internet consulting giant where I fell smack-dab
into the dot com bubble. Boy! Was that a comfortable bubble to be
in! We did not question our motives as designers; we simply churned
out stylistically correct work and were very well rewarded for
doing so; free massages, arcades, fruit, sodas, and a damn great pay-
check. So why question it all? It was good times and we had no
time whatsoever for design criticism. We all had to get to the next
"launch" party.

During this time I developed a very safe and oh so very clean,
yet bold, style of design that allowed me to stand out in our little
internal competitions to see whose design the client would pick.
It worked. No one seemed to mind it, much less question it. So,
why should I? *Fortune* 501 clients, Chief Creative Officers and Art
Directors within our organization praised my work. I guess I knew

better than to fall for all that, but it felt good. This was design in the late 90s and by God I was in the middle of it! Surrounded by overpaid designers caring little for the meaning of design or its consequences, but always anxious for the next Attik book, or buying whatever David Carson was selling. Big time love for style and trends; swooshes, transparency, pixelated images. You name the style, we adored it, revered it, regurgitated it with a .com at the end and cashed our checks.

I am not using any of this as an excuse. I am merely painting a picture of what it was like being a young designer after "The Legibility Wars" were over and nobody had invited any of us to put up a fight. In reality we had nothing to dispute; all was perfect. At least on the surface. Branding became cool; creative agencies were making money up the wazoo (so was anybody using Etrade) and I'll say it again: graphic designers were very well rewarded for little effort.

Can you see the trend?

Superficial design = Great paycheck

Following trends = Client happiness

Not questioning your profession = A nice, well-placed, fanny pat

This is what I went through and why I think design criticism wasn't even an option, much less a necessity. I obviously can't speak for a whole generation across the country, but I'm sure I saw enough to notice that the state of graphic design was not an important issue. We were all more concerned in landing the next big client and we did that by being stylish, not critical. Styles were many and easy to copy as long as you had the right tools and were in the right place. If you worked in San Francisco, lots of bright colors and bold white typography were all you needed. In New York? Simple: a black background, some beautiful serif type—smallish—and you were set. In Atlanta, where I was, well... we just copied the best of both coasts with some southern flavor (it lacked taste, in my opinion) and then just went on to ShowSouth to collect our awards. Not a bad deal, really.

Eventually all this wore off, a big percentage of dot coms went bye-bye, people got laid-off, new styles (yes, Modernism 8.0 among them) surged, and four years later we are at war questioning every-

thing from the Dixie Chicks to our own profession. Apparently, the only ones writing about it are cranky old designers (did I mention these are not my words?) who, like any older generation, abide by "things were better back in our days" nostalgia. There is nothing wrong with that, perhaps they were better days, but I can't get over this feeling after reading "Rant" that there is supposedly nothing worth looking at today. Well, I beg to differ... and to agree.

Once again I feel part of the problem. As opposed to many writers and designers, I can accept that, at this point in my career, I am not proposing any visual revolutions with my work. Far from saying that my work sucks, I still can't help but feel that I could do more. Not better necessarily, just a stronger effort in trying to create something new and different... but why? No, really, why?

In a recent interview with Rick Valicenti for Speak Up, he mentions that prospective clients have considered his work too "extreme" and "aggressive," to which he added: "What was once an asset appears to now be perceived as a liability. So much for 25+ years of practice." What that says to me is that potential "corporate" clienteles—which in turn have their own clients and in turn could quite possibly end up being your neighbors—are not looking for work with emotion and personality, much less a thoughtful message. What they are looking for is something familiar, perhaps a solution that has already worked for others in their particular field and was, rather likely, designed by one of (y)our competitors. Style follows profits. We need to remember that we are a service industry, we are here to serve our clients' needs, not the canons of design criticism.

Another claim I have heard many times lately is the lack of "experimentation" in graphic design. Andrew Blauvelt said "The late eighties and early nineties produced an assault of the conventions of graphic design through an intense period of formal experimentation. Those inquiries were a desire to rethink prevailing assumptions..." Perhaps, with all due respect, there is nothing to rethink at this point. It seems that as long as we stay true to pre-approved styles of design, we will be very well rewarded, both by our clients' happiness and continued working relationship and by design annuals commending such work. The moment a design

annual says "We are sorry, we are not showcasing anything this year because no good work was done," that's when we will try to come up with something new. Until then, we will keep regurgitating styles. A focus group would have to say "We want something different, not the usual visual crap we are accustomed to seeing" for us to make an effort to surprise people with a new visual vocabulary. Graphic design is a reflection of the world today and nobody is looking to take any risks right now, so why mess with what little harmony there is, if there is no need to? As long as nicely kerned Helvetica keeps the world going 'round designers will keep using it.

As part of the 80s/90s experimentation epoch, some of the work that most stands out in my mind was done by Ed Fella, Elliott Peter Earls, and David Carson. Kenneth Fitzgerald pointed out—regarding Sagmeister's work—"Designers' scrawls are common, and Ed Fella's have proven far more influential and individual." Influential for who? For designers? Certainly. For Sagmeister? Probably, but how have Fella's scrawls influenced the visual culture we live everyday? Believe me, I have the utmost respect for Fella's work and I don't question his contributions to the field, but I fail to see how it affects mainstream culture. Mainstream culture is life. That's all there is to it today; if it's not showing on DirecTV nobody knows of its existence. How has this "formal" experimentation affected culture? Where can one marvel at Earls's fabulous work? It is stranded in every poster lining the halls of Cranbrook, all dressed up with nowhere to go. David Carson was able to affect mainstream the most, pushing the boundaries with work for Armani, Pepsi, Microsoft and other highly visible companies. Where is all that today? Better yet, what is Carson doing these days worthy of discussion? My point is, one more time (and all together now), experimentation is not being rewarded in today's economy. I don't see how a designer would choose "experimenting" over doing some nice corporate brochure that is bound to bring in business and pay the rent. I am not saying that the only reward one should expect is financial remuneration or *Best of Shows*. I just don't see many reasons out there—challenging Modernism is certainly not one of them—to take major risks. Sadly, today might not be the best time for designers to be thinking about questioning the conventions of graphic design.

SO WHERE ARE WE NOW? Why are we so adamant about recognizing what is good in graphic design today? There are many things to get excited about and certainly many more to frown upon. Following are only a few of the styles shaping graphic design—some good, others not so good—that are worth mentioning.

NOTE TO READERS:
No disrespect intended,
just telling it as I see it.
And willing to say it.

The Cahan School of Visual Arts

I could probably go as far as saying that Cahan and Associates' work has proved the most influential for today's designers. Every designer working for corporate America aspires to this Cahanesque order of beauty, cleanliness, and simplicity, where any man can get in touch with his feminine side and still be bold, and a woman can flex her muscles by using strong slab-serifs. Full-page bleeds are no longer a necessity, and a proportional thick white border separating the photograph (and/or a solid color) from the edges of the page goes a long way. Financials are treated like princesses. And graphs take on all shapes, sizes and colors, even if sometimes they become indecipherable and inconsequential or gratuitous—otherwise now known as "Infauxmation Graphics." But who cares, right? Nobody reads anymore.

(A fun activity for a rainy day is going through design annuals without looking at the credits and trying to figure out if the work is a Cahan Original or a forgery. Try it, it's fun.)

If admissions to The Cahan School of Visual Arts are no longer accepted, try other venues like VSA Partner's Expedited Courses (where you probably won't last more than six months,) or Samata-Mason's more intellectual programs.

Getting their Hands Dirty

It is quite obvious that desktop publishing is here to stay and hell yes, the computer has created a homogenized style of design. So it comes as no surprise that any time we see design "done by hand" we are immediately drawn to it. Aesthetic Apparatus is the perfect

example of the good ol' days when creating good mechanicals
was a craft. Walking the fine line between artists and designers, they
remind us that the hand is faster, smarter, and more talented than
the mouse.

I am surprised that James Victore's name rarely comes up. Who
else, in this day and age, has the guts to do what he does? Basically,
doing whatever he wants—with no concern for "beautiful," he
is able to focus on the message and the repercussions that his work
can provoke. I have tried many times to somehow describe Victore's
work, sat for hours trying to come up with a decent adjective or
witty soundbite; then I realized what's special about it: it makes
me want to swear. And that is the biggest compliment I can manage;
nobody else's work makes me want to swear. It's a raw reaction,
just sprouts out of my mind and there it is. Fucking amazing.

Another dirty-handed designer is Sagmeister, who in my opinion
is more than "naughty by nature," the one designer willing to put
his balls out there for lopping. Paula Scher got in on the action with
some of her own rather frantic and obsessive drawings of maps and
all the numbers in her life. Of course, Art Chantry is another great
example, but more on him later.

Minneapolessy
No city in the U.S. has a stronger, or more apparent, overall design
style associated with it than Minneapolis. It is your grandma's
scrapbooks on speed. Heavy ornamentation, earthy colors, deep lay-
ering, confounding patterns, and lots of vintage cool define the
style. With design firms on every corner of the city, Charles
Anderson surfaces on the top as the one who made retro cool, very
marketable (just ask French Paper) and set its pace with his, as we
kids say, "mad talent." More than that, Charles has set the standard
very high for any designer looking to imitate him. Yes, there are
many of those.

The women of Studio d Design and Werner Design Werks keep
up excellent and strong work, yet it seems like they have found a
formula that keeps getting applied over and over with (amazingly)
rather effective results. The Minneapolis style is hard to mimic
if you are an outsider; even people in its twin city have a tough time
emulating it.

Eat-off-the-Toilet Clean

Two of the most common terms I hear as of late are "Beautiful
Design" and "Beautiful Typography." I could try -explaining it, but
I'll just dwell on the perfect example: this year's AIGA 365 annual
(*365: AIGA Year in Design 23*.) Not the work contained in it, but the
book itself, designed by Rigsby Design in Houston*. The book is a
perfect example of what restraint, balance, and a nose for typogra-
phy can achieve. It is so nice and clean (it even smells good) that
when I hold it in my hands I can almost feel like a better designer.
But these same qualities can work against it: lacking persona or
charisma, it feels untouchable and unreachable. It is, as it has been
said before, as if no designer left his or her personal imprint on the
book. No soul. Only beautiful nonetheless.

Chen Design Associates in San Francisco, Pentagram (all over
the world) and, one of the newest members of this club, Bamboo
Design in Minneapolis, are all creating beautiful, effective solutions
for their clients. Maybe they are not groundbreaking solutions,
but not everything in life has to be a home run.

Frozen in Time

I commend anybody sticking to their guns, but to be successful,
designers must keep developing their personal style. Even if
it is very marked in nature, there have to be little glimmers that
reflect its constant growth and evolution, becoming better and more
effective. If a designer's personal style becomes stagnant, it can
become a liability for clients, as the work will look old, dated, and
probably not be very effective nowadays. I have been watching
Segura Inc.'s work for about eight years now, and it is the same now
as it was in 1995: industrially hip (even MTV has outgrown that
phase), There have been some improvements here and there and
some flashes of brilliance that remind us of why we all fell in love
with their body of work, but overall it is the same language used
over and over for all of their clients.

Art Chantry's work, some of the most inspiring of the past
decades—triggering our rawest emotions and feelings—also seems

* This style breaks all regional barriers and can be appreciated all over the country

to be stuck in the Punk 80s. Perhaps his style is very appropriate for the type of work he does, but I'm not sure how relevant it is anymore. I hate to say it and I fear being stoned at the next designer gathering, but his work is becoming repetitive and expected. It is still of great quality and craftsmanship, but the element of surprise is just not there anymore.

Other examples are Chase Design, stuck to their Gothic-chic look, and Sayles Design, who should start thinking about bringing their black strokes to one pt. instead of twelve.

A Breath of Fresh Air

Constantly challenging themselves and the rest of us with new graphic solutions are firms like Open, Honest and Doyle Partners, developing excellent and dynamic work while at the same time meeting client needs and wants. Karlssonwilker, the newest kids in town with an attitude, are creating some of the smartest and wittiest design today. 2 x 4, Design MW, Hillman Curtis... the list goes on and on. With great work, ever evolving style, and more importantly, developing with the rest of the world and its culture, these firms are a joy to watch and are a great example of what is extraordinary in graphic design today.

I just realized all these groups I mentioned are in New York. Perhaps the great work is a direct reaction to the events of two years ago. Could great, transcendent work in graphic design be the reaction to tragedy? Maybe it's a sense of I'd better do it now rather than later, because later might not come so easily. I'm far from being a political, social, or war analyst, but I find it rather interesting that right now the best work in the u.s. is coming from the Big Apple. Whoever says Austin, Iowa, or some small town with big-city dreams is at the forefront of design better check their calendars. It's 2003 and New York is it. I don't even live there and I can feel it.

That's what I see when I stick my head out the window and, to be honest, I like it. We are seemingly far from the wonderful days of experimentation, of asking ourselves "Is this readable?" and I am endlessly grateful for the doors those activities opened. We are further from the days of Bass, Tibor, and Rand and it's a shame to see some of their iconic work bastardized with, as was stated in UPS's

rebranding media kit, greater visual impact, but I don't think that wallowing in the past is a smart activity. We need to look forward. Pointing out current flaws and trends in design may very well be part, and just the start, of a bigger process in getting back to stronger discourse. One where the flow of dialogue is two-sided and collaborative, creating paths for new ideas and processes, and maybe a stronger understanding of where we stand as a profession and where it is we are headed. The mere act of indicating flaws and blemishes within the boundaries of graphic design should not be the only ammunition of choice among design critics—somebody must be willing to actually propose something... anything, at this point. In the same realm of responsibilities, more walk and more talk is what we need from young designers. I don't think it's a battle between us (young pups) and them (old pops), but I do believe that if it's all left to the older generation, the perceptions and opinions expressed will be skewed to fit their views. Even if this is not that bad a scenario, it's just not balanced enough for easy digestion.

Probably, I wouldn't mind seeing some changes around here [the graphic design profession.] I guess I need to start with me.

This is my kick in the groin. How did that feel?

Armin Vit is a youngish (for now) graphic designer in Chicago, Illinois with roots that stretch as far as Mexico City. Feisty on the keyboard, yet timid at heart. Vit founded the design forum *Speak Up* due to incessant design-related brain clamor.

Design Idol

Mike Kippenhan

WHEN I STAND IN FRONT of my graphic design students to discuss the latest happenings on Fox's TV series *American Idol*, I'm met with strange looks of bewilderment and scorn. My students don't believe that I watch—I do. However, I don't watch *American Idol* for the music—rather, the interaction of the judges is what keeps me coming back. I'm interested in their perspectives and comments, how the contestants respond and how this exchange is greeted by the audience. After a season of *American Idol,* I'm left with the belief that this program offers a good model for graphic design to kick-start a new dialog.

In case you don't watch *American Idol*, let me give you a quick synopsis. The program is a successful merger between music and TV that utilizes the best ingredients from the entertainment, reality, and audience participatory programs that preceded it. Starting with a field of around fifty thousand *Idol* wannabes from across the US, quick thinking judges work to narrow the field down to about two dozen. After this, the remaining contestants perform live on TV and they continue to have their performances critiqued by the judges; but unlike earlier rounds where judges decided who stays and goes, the viewer decides. By calling in their vote in a weekly process of elimination (one tally numbered over 23 million), the field of contestants is narrowed down to the *American Idol* of the viewers' choosing.

American Idol is a complete package. It's not about having "connections" or performers being promoted to fit a marketing niche; it is about talent being chosen by the people that will purchase the music. In tough and uncertain economic times, the program offers viewers an escape with its brand of unbridled enthusiasm and "can do" feeling. This claim cannot be made for graphic design. As a profession, designers sit here just three years into the new century suffering from a lack of energy and the feeling we were just socked in the gut. The economic downside of our times has been taken to

heart. This is paradoxical, for as tough as the business side of it is, the visual side seems to be moving at a brisk pace. We are witnessing a vast array of styles and production methods working to create a veritable field day of visual delight. The computer and Internet have been in the studio environment long enough that their novelty has worn off and their potential as creative tools has matured. Global brands rely heavily upon graphics to differentiate their product in the ongoing need to fuel our consumption-crazy-planned-obsolescence-what's-hot-now culture. A quick glance at anything from "Cultural Creatives" targeted goods to self-published work testifies to the visual richness of our time. Even the once boring department store has gotten into the swing of things, as witnessed by the work created for Target. We live in an exciting visual time.

These visual riches bring up some important questions. Is everyone comfortable in the midst of this stylistic variety? Are you worried that the "style" you work in will become old—remember the "layered" look? Can you keep up with what was fresh last month, what is fresh now, and what about next month? Are you reinventing yourself to satisfy the fleeting needs of a client? Are you secure knowing that the tools of our trade have been decentralized to the point where anyone can create work that was once restricted to experienced professionals? Conversations along these lines are important. Anyone care to discuss them? Anyone?

No response. So it's only natural to seek this dialog in graphic design publications—our public voice. They potentially offer the designer, who's been stuck behind a computer all day, the opportunity to view our profession from a global perspective. Why not? They are the most ubiquitous and accessible voices that connect the design industry. However, a quick glance at mainstream American magazines such as *Print*, *Communication Arts* and *How* illustrate that we're stuck with the same tired "Show and Tells" and Annuals that we've seen for decades. What we find are publications offering only superficial dialog, momentary entertainment, and a lack of any real insight. They appear to have taken the philosophy of so many American brands, where image is everything, holding on to your piece of the pie is mission one, safety is the rule of law and "for God's sake, don't piss anyone off; we might get sued."

Unfortunately, those of us seeking legitimate dialog must battle the standard set by these publications, whose shallow content has become the de facto model for the industry. Graphic design's most visible and accessible representations of our industry are failing to help capture a sense of what is happening. The *zeitgeist* is reduced to glossy photos and simplistic captions. How utterly weak-minded we've become.

Even though the graphic design industry has gone through many monumental changes in the last 20 years, there doesn't seem to be any dialog within the industry to address these changes. Instead, we happily go about our work hoping a budget won't get cut or the client will approve our comps. Self-reflection and assessment have taken the form of glossy portfolio reviews—"Look what I made!" What becomes problematic with this approach is that as designers we avoid challenging ourselves, our work, and our role in society. This in itself is funny, as tough critiques are seen as an essential part of design education; however, when we become practitioners we want only admiration. We fool ourselves into believing these easy-to-digest "Show and Tells" represent a form of dialog. They clearly illustrate that as graphic designers we have become afraid to offer the critical voice that may, if given the opportunity, strengthen our profession. Designers fail to understand that superficial dialog only deadens our minds and fails to spark our critical spirit. Ultimately it will become the accepted manner of speaking to one another and hinder our evolution.

If we truly believe our services are a vital ingredient in a complex society, we must begin to communicate this. We need to get beyond the practice where only journals with limited distribution and press runs offer critical voices, while the most visible have carte blanche to create only fluff. Graphic designers must embrace the idea that participating in a critical dialog is as essential to our profession as the products we produce. So how do we get the ball rolling?

As laughable as using *American Idol* as a model may sound, at least it offers the viewer an understanding of what it takes to "win" and the participants a critique as to what it takes to become an "idol." This elementary but critical dialog presented on a mass level is more than is offered by graphic design. What *American Idol* does well and

what makes the program compelling (graphic design take note) is the panel of three judges, each with their distinct personalities and perspectives, who instantly critique the contestants' performances. First is Randy, who can deliver either positive or negative critiques in a hip, street-smart style. In the middle is Paula who, barring a horrible performance, sees everything as wonderful and believes that everybody is a winner. Last is Simon, the no-nonsense, hard-to-please judge who oftentimes leaves the performers and audience gasping at his bluntness. But this combination appears to work; they may not all agree, but the collective input offers a pretty good sense of what is happening.

Each episode of *American Idol* allows voting only at the end of the program; thus, viewers are exposed to the three judges' opinions, often conflicting, and must weigh these against their own prior to voting. In this formula, the viewer becomes an active participant in a dialog in order to get their reward (i.e., the next round of voting and selection). In the long run it makes the viewer a more discerning customer and gives them ownership in the product. This is more than what can be said for graphic design, which appears to have the desire for the one voice, that of Paula—an incessant cheer-leading. However, the fact stands that negative reviews makes the glowing ones all the more relevant. If the viewers of *American Idol* (most of whom appear to be under 18 years old) can participate in a dialog, why can't the design industry?

Graphic design obviously needs a strategy to kick-start some sort of dialog. To do this, the industry can borrow the *American Idol* model—there can be a band of judges that crisscross the country searching for the next big thing with designers voting on what they like. We'll call it *Design Idol*. In an attempt to represent multiple voices and perspectives, judges will be chosen from throughout the profession, not just those associated with the country's hothouse design studios and schools. They'll look for all forms of work, from all corners of the country, representing every possible project and client. Rather than fall back on the tired "Annual" format, selected work will be posted on a web site for viewers to vote on. And to make it more interesting, the names of the creator will be left off— why not judge work on the strength of the piece instead of the

reputation of the designer's studio? Within days votes can be tabulated and the winners can go to the next round. After a few rounds, a group of *Design Idols* will have been selected and they can become the inspiration for the industry. And if you're not happy with the choices, don't fret, a new competition will be starting soon—after all, fame is fleeting.

On the surface, *Design Idol* may reek of the trivial pop culture mentality that graphic design pretends to be above. However, it can be a mere vehicle for important agendas, such as creating energy in troubled times and circumventing mainstream design publications to force them into rethinking their content. It will also be an opportunity to see and hear design voices that are otherwise overlooked. Imagine the excitement when entering work into design contests when the playing field is leveled and designers' names and studios have no bearing on the results. But most importantly, in the process of voting, the participants will have witnessed the fun that a critical dialog can offer. They will see that criticism isn't always negative, and that honest analysis of their profession will ultimately make it stronger. No matter where a designer is from or what the scope of their work is, they can be a voice in the profession. By doing so, graphic designers can approach their work with confidence derived from having participated in a meaningful dialog, rather than the bravado of magazines seducing them with surface treatments. After a few rounds of *Design Idol*, who knows what will happen or what the next big thing will be? All I know is that it offers a plan that is more than we have now. And hey, it will probably be fun to boot.

Mike Kippenhan is a designer and educator living in Portland, OR. In his free time he can be found collecting insects. (www.compoundmotion.com).

"You mean we have to read this?"

by Anthony Inciong

TEACHING GRAPHIC DESIGN at a private institution on the Jersey shore has its advantages. The most obvious is the relative solitude of a suburban environment conducive to focused study. A disadvantage is the feeling that we constantly live in the shadow of New York, which makes my responsibility as a design educator all the more significant. My students need jobs and I have to make sure they are good enough to acquire them.

But was my teaching up to par? Will they know enough at the end of four or five years? Will their portfolios be strong enough? The spring semester has passed, another year just ended and I am left wondering if I was able to enrich the lives of my students. Do they understand the significance and purpose of graphic design now? Have I effectively clarified the process? Did I make graphic design interesting? I ponder the ramifications of the above as I stand in the doorway of my office staring at the quaint cobblestone courtyard that identifies the Department of Art & Design. The West Long Branch air is still cool. I look up just in time to see dark clouds rolling in. Looks like rain.

"Why do you teach?" asked a colleague. "Why are you here?" My reply? Something about teaching sustaining me; that it's one of the most difficult jobs I have ever had but that it's worth it because I enjoy working with students and watching them grow. I meant what I said, though my reply only addressed part of the reason I teach: I teach because I believe graphic design is not simply about beautification and the proverbial "solving" of "problems." Looking at my students' past projects, I cannot shake the feeling that I haven't done enough. Where there is richness of form there is also a lack of content. Good looks and absence of meaning makes design a vapid thing. Isn't graphic design about content? Isn't it about ideas?

Graphic design education, now more than ever, must address the broader issues facing the profession. Amidst sociopolitical upheavals

of late and ever-advancing technologies (for better or worse), it is vital that undergraduate programs take an holistic approach towards teaching graphic design that will surpass purely formal concerns in the service of industry. Educators must cultivate a spirit of inquiry within their classrooms that will transform their students into highly motivated and capable designers who are incisive critics of their work. Students must be made aware of the choices they make, as well as the strategies they employ against a much larger backdrop of events and circumstances that defines the world beyond their classrooms. They must know and value their roles as empowered shapers of culture, a fact that must be communicated to them early during their academic careers.

A foremost concern of many design programs is that its graduates be well rounded and capable of providing competent, sophisticated service through the visual language of design in a professional environment. "Service" implies that designers have a responsibility well beyond their own penchants and that to design for an audience means that they are communicating messages visually to and for a particular community of people (society) whose culture (way of thinking, beliefs) they inevitably influence. However, issues of audience and culture will not be a concern to students if they are not emphasized or brought to bear upon projects and lectures within the classroom. It is difficult enough to convince initiates of the viability of design—this is especially true for those who have meandered into the field not due to any overarching belief in its efficacy but because they see it as a means of earning a living while pursuing an interest in art. Such a myopic outlook leads them either to think of design as a private activity or to think that design begins and ends with the client. An environment must be created in which students analyze their work deeply and in much broader terms. Critiques must be elevated to a point where students articulate their intentions and opinions while asking incisive questions about their work and the work of their classmates. How will a design be interpreted? What other messages might be gleaned from a design that is a byproduct of the process and invisible to its maker? Is it sexist? Racist? Misleading? Condescending? Contradictory? Critiques are not celebratory. They are investigations, a dismantling of sorts to

reveal a designer's motivations. "I like it." "I really like it."
"It's good." "I really like the colors." "How did you make that
effect?" "It's cute." Such stomach-turning superficiality virtually
guarantees graphic design as nothing more than typographic
and imagistic onanism.

Despite our lackluster economy, there is no doubt that there is still
a continuing increase in graphic design majors at colleges and uni-
versities. New subjects are being taught; new facilities are being
built and older ones expanded in support of new areas. But the real
issues of keeping students focused, transforming them into masters
of design methodology, supplying them with the information to
become well-versed in design history, inspiring them to take an
interest in events that have shaped and are shaping their culture,
teaching them to articulate their ideas, and teaching them to learn
to work quickly and intelligently with technology in a fast-paced
and constantly changing environment still remain. Unfortunately,
given the emphasis on technology, it appears as though graphic
design methodology—strategies and procedures from which stu-
dents learn to produce meaningful design—is losing its appeal.
Educators must emphasize to their students, many of whom take
for granted the position they are in to influence and educate audi-
ences, that learning the mechanics of software (though a necessity)
does not provide the content that will validate the form their graph-
ic designs take. There is a misconception among undergraduates
that technology will solve the issues for which they are accountable.
Sadly, that frame of mind is also content to eliminate the pleasures
of exploring ideas through sketching, research, and writing, all of
which are part of the design process. And here I thought design was
a form of art driven by an insatiable desire to know about many
things! The focus has gradually shifted from students challenging
themselves formally and conceptually to learning the features of
whatever software or hardware they must use to complete a project
for a deadline. Want ads, which reflect the way the market perceives
designers, perpetuate and reinforce this tendency; for example:
"Graphic Designer—So CT area. Proficient in Quark, Photoshop &
Illustrator. PT position. Res to: PS Design Inc, 114 Peaceable Ridge,
Ridgefield, CT 06877 (*The New York Times*, May 26, 2003)."

In order to graduate well-rounded designers with the potential to become deeply involved in the development of content (as opposed to just doing what they're told), adjustments must be made to the way graphic design is taught regardless of the curriculum. The following suggestions should be thought of as principles to be espoused by design educators rather than as a set of rules to be followed. If design is a public service, then the following should lead us back to our audience and to the kind of graphic design that will enrich our experience and serve our clients.

Graphic design cannot be taught from an exclusively formal standpoint. Methodologies must be discussed within the context of project requirements and limitations, including such questions as: Why does a design look the way it does? What do certain elements/ graphic devices mean in relation to the project? What, ultimately, is the designer trying to impart to an audience/viewer/ reader? Where and what are the weaknesses and strengths of the design? How can it be improved? In addition, solutions must be realized through aggressive visual/formal experimentation guided by a body of knowledge culled from research. (My use of "experimentation" here means a rigorous approach to problem solving rather than the exploration of theory.) Metaphor and symbolism must be employed in order to captivate audiences, thereby making them part of the design process.

SOFTWARE AND HARDWARE INSTRUCTION must not be discussed in a way that leads students to believe graphic design precludes ideas. Doing so places far too much emphasis on the mechanics of production rather than on content. The use of technology must be tempered by conceptual and aesthetic concerns. Design as an intellectual and interdisciplinary activity must be approached in a scholarly manner wherein students view research as a point of departure and sketching and/or writing are a necessary means of exploring possible solutions. Anything less is trade school pedagogy.

Mining graphic design history for new and appropriate forms serves students best when exemplary works of a period are not merely discussed in terms of their look. Graphic design artifacts should be framed by discussions that examine the social and

political conditions that fostered their development, rather than viewed as a collection of styles to be picked up or dropped as needed. It is through the study of history that students acquire a vocabulary of design that helps them clearly describe the strengths and weaknesses of their work and the work of their classmates.

The responsibility of educating students does not fall entirely upon the shoulders of teachers. Students must learn to be proactive. Somnambulism is the nemesis of graphic design education. To declare oneself a graphic design major necessitates an absolute devotion to the study and making of design. There is an alarming tendency among undergraduates to want to be led to a solution. "I don't know what to do" and "What do you want?" are common traps. While it is all right for students to be uncertain about how to approach a problem, it is unacceptable for them to consistently come to class empty-handed. In this scenario the teacher begins to solve the student's design problem. "When's this due?" There is also a compelling need among students to finish assignments as quickly as possible, which limits their exploration. Indeed, given the preponderance of technology and time constraints, exploration through sketching and writing might seem like an annoyance. It's quicker to design on the computer and yet, without a plan, this strategy rarely leads to resonant work. Where is the joy? Where is the curiosity? "You mean we have to read this?" It is rare to find students who take pleasure in reading. It is rarer still to find one who innately recognizes the connection between graphic design and language. Students long to make but don't wish to know. Reading and sketching takes time but spinning one's wheels can be endless.

Emigre's "Rant" gets us thinking again about why we're here and why we do what we do. From an educator's perspective, to teach design is to teach not only the means and methods by which form is given to ideas. It is also about intelligently speaking to and about culture—giving back rather than taking from it, representing it, defending its virtues, and questioning what weakens or endangers it. Educators are privileged to be in a position to lead by example. I believe that there is something greater than the "market" which, unfortunately, tends to view graphic design and its practitioners as commodities. Graphic design as beautification limits the extent to

which designers can become involved with the development of content. Maybe the market is afraid of what might happen if designers cross the line? Maybe it's afraid that we might actually know a thing or two about what people like and don't like being consumers ourselves? Is it afraid that we might see right through an insipid strategy? Whatever the reason, I/we cannot sit idly and accept that we are vapid stylist yes-women and men. If we do, graphic design becomes impotent. If we do, it means we agree that there is nothing more to graphic design—nothing more to us—than technique. If we do, we agree that there is nothing more to our work than the revenue it can generate for a client. If we're going to "do" design, we ought to do it well and have the courage to ruffle a few feathers. Though graphic designers are rarely in a position to completely alter the way employers do business—the machine is too big and its roots are too deeply set—just knowing that their work can shape the environment and consequently influence the way people perceive the world enables them to question dubious strategies and be rigorous in their pursuit of solutions while effecting change quietly from the inside. Viewing design education from this perspective should remind educators that they are empowered to impart to design students a set of values that will enable them to excel at what they do and be responsible citizens.

Anthony Inciong is a Specialist Professor at Monmouth University's Department of Art & Design where he teaches undergraduate courses in graphic design, typography, and motion graphics.

Dear Emigre

by Patrick Fox

I RECEIVED ISSUE #64 IN THE MAIL YESTERDAY, and at the risk of jumping the proverbial gun, I was prompted to write to you shortly after finishing RvdL's intro. Hooray! Your delayed "Rant" arrived at a time most appropriate for this discussion to begin. The reality is that today is a very difficult time to be a designer, if only because of the perceived notion that we designers exist to merely "ice the cake" (someone once said this to my face) and are therefore superfluous. My current reality has changed dramatically since being laid off January 2002—I had at one point found myself questioning my very existence after 13 months of unemployment. The Law of Averages states that perseverance pays off, but I did not know just how long this would take. *Pro bono* work kept me focused through 2002 and eventually led to a paying gig that stopped the credit card companies from calling. Before that happened, however, I was asked by the editor of *Design Madison* magazine to write 1400 words on what it means to be in the creative class and involuntarily unemployed in Madison, Wisconsin. Since my dry year, I have found sustainable design work once again. I have been creating campaigns for the American Red Cross that have brought much attention to our Badger Chapter, and I have been producing health and sexual awareness campaigns for University of Wisconsin students. In addition, I was hired part-time to create campaigns for a nationwide telecommunications firm. And I freelance as well, making certain to educate my clients on why I choose certain fonts and imagery for them—the meaning behind design. Somehow I manage to balance all of this, when a year in the past I had nothing to balance, not even a checkbook. Two weeks ago, a Madison, Wisconsin designer was arrested for robbing a bank and a few food stores and, while some thought it humorous to clip the article for me, I could understand the creative desperation this man might have felt. I was there. In my down time it became clear to me that my desperation should be focused on critical thinking about my profession, not desperate acts. This would

not only raise the bar for myself but for all designers; conversely, this designer has done on a smaller scale to our profession what the Hell's Angels did for motorcycles. I just wish I could have told this designer what I had discovered. Communication will prevent these things from happening.

So begins my "rant." Just wanted to share with you. I am about to attend a press check for posters created for the same telecommunications firm (2 color, 273 + custom metallic), requiring me to ride my '82 motorcycle 15 miles through Wisconsin's drifting country-side on this sunny 65° Friday morning. Keep up the great work, folks. Below is my article that was written during the lean times, for whatever it is worth.

Life During Wartime

Or Unemployment Survival 101

6:15 am

I STILL WOKE UP WITH THE SENSE of preparedness for the new day. I was propelled forward much the same way the *faux* model Ts at amusement parks know how to steer, sans driver. There is a track laid down for every individual, and it takes a discerning eye to see it, but once you have found yours, you might call it your passion. As long as this passion endures, the trajectory will remain, even if one slows down, speeds up, or runs out of gas entirely. Sometimes, though, one might jump that track—and that was what happened to me. After years of designing, I neither expected an off-ramp nor was aware that my exit was coming up. I was laid off.

I sensed some signs, but I was road-weary. There was a palpable change long before the September 11th attacks. I watched as co-workers and friends were told they had the day to pack their stuff. Talented, considerate co-workers. who were pouring all they had into their work, were being cast off by management. Evidently, it was time to cut personnel rather than unlearn the status quo, take some risks. Big changes. Then: my turn. With a small severance in hand, I was determined to continue in graphic design.

9:00 am

I SAID GOODBYE MANY TIMES each day, first to my girlfriend who
successfully recovered from an eight-month lay off. She is once
again a gainfully employed graphic designer. I also said goodbye to
my new friends Nicole Phillips and Charlie Shortino from the
NBC15 StormTeam Weatherlab. Something was not normal. The
reality of my surroundings was settling in, my membership card to
society had been suspended, I was unemployed. I fell into a burning
Ring of Fire; my love had let me down. I felt a certain destiny call-
ing, and it didn't include befriending Katie Couric and Matt Lauer
and their sugarcoated morning reality. Successively, I began to turn
off the TV earlier. I needed to re-tool.

9:30 am

MONTHS (YEARS?) OF REPRESSED DESIGN IDEAS surfaced as I began
to conceptualize and design posters, produce hand-bound books,
postcards—I felt liberated! Years of hoarding and ingesting *Emigre*
magazines, being enlightened by the concepts of Tibor Kalman,
pondering the innovations and pain of Sagmeister—mixed with
my current unemployed status and created these wonderful messes.
It was finger-painting for the 30-year-old. A renewed interest in
"design as social purveyor" fascinated me. Graphic design is much
more than just selling the newest-in-new, which I knew all along,
but this tends to be where most designers find themselves. Can one
make a career serving a client's needs and fulfilling personal pas-
sions? Are risks being avoided in lieu of comfort food and safety
nets, a sign of the times? With trust, one is able to take risks and cre-
ate truly innovative work, truly an attainable goal. I needed to
unlearn a thing or two myself about design and commerce—mainly
that a designer does not need to "sell out" to sell something.

11:30 am—3:40 pm

DESIGNING OR NOT, I NEEDED AN INCOME. A disenchanted designer
friend temporarily quit the business to deliver baked goods and
enjoy free coffee and sunrises along the Lake Michigan shoreline,
a self-imposed sabbatical. I admired her for doing it, inspiring me
to seek out what services were available to people in my position.

The federally funded Dane County Wisconsin Job Center (608.242.7402), located at 1819 Aberg Avenue, offered many computer terminals for searching a statewide job database, books, and literature on building résumés and cover letters, as well as a knowledgeable Coordinator by the name of David Skattum. He said that the people using the facility consisted of thirds—one-third unemployed, one-third working and looking, one-third looking for a second job. Out of thousands of available positions, I discovered one sole design position, though he did point out that their system cross-referenced skill sets and listed other jobs I might enjoy.

Much different and more intimate, the University's Job Search Support Program (608.263.6960) offered individual attention and the chance to share your insights within a group. Meeting on Wednesdays at the University of Wisconsin's Memorial Union on Langdon Street from 10 am to noon, anyone can return each week and all were given the opportunity to suggest how one might improve his or her approach. This particular day, there were eight of us, including counselor and facilitator Sybil Pressprich, who pointed out that networking is critical: "Over two-thirds of new jobs are landed with the help of people you already know." She said that six months is the typical duration needed to re-establish one's career, and a good use of that time is to re-evaluate, take classes, or maybe start an exercise program. From books and handouts available there, I discovered that avoiding isolation and the feeling that nothing is being done is the best thing you can do for your psyche. Call on your friends when and if you need help. That day's topic was salary negotiation and after some discussion, I decided to continue to approach each job opening with my love and need to do that type of work, since money for me tends to sabotage my motivation.

6:30 pm
MY GIRLFRIEND ARRIVES HOME FROM WORK: an 11-hour day today. Her work ethic inspires me and her enthusiasm is contagious. I continue to start my day at 6:15 am and approach each day like a full-time job. I am reminded of what I love most about graphic design, and not surprisingly, it was more than the work: it was my

co-workers, the people I was spending one-third of my life with that made working and work possible. Working creatively means you get to embrace other creatives. How great is that? Remember the last tri-fold brochure you worked on? Was it the sixth in a row? There is a fine line between a groove and a rut! Maybe it was that mid-afternoon walk to Michelangelo's coffeehouse with a co-worker that afforded you a fresh perspective. Was it an impromptu game of office shipping tube bowling that jolted you from the 3:40 pm doldrums? The Muse is called forth by the spontaneous fusing of you and your creative cohorts and the need to conjure an innovative concept. Fun in the Workplace: not a new method but an often overlooked and vital one when creative thinking is demanded. Damn, I miss that the most.

9:30 pm
"EACH DAY JUST GOES SO FAST/I TURN AROUND, IT'S PAST", lamented Mr. Harrison. Even with the appearance of a lot of it on my hands, time slips by exponentially. Barely making it through the weather portion of the 9 pm news, we begin our nightly rituals while we discuss *pro bono* work, designing for charities, Adbusting and maybe someday setting a sign out front to begin designing for our own clients. And on the Joy of Networking: once I got past the rather despondent-sounding term, I discovered that it means quite simply getting to talk with other people equally passionate about the same topics. The stigma quickly dissolved, and it has now become the most enjoyable part of being laid off. In fact, if it weren't for the people I meet everyday and who have generously given their time to talk about what they believe to be true in this world, I might have also been delivering baked goods by now. Instead, I hold on to the belief that graphic design provides an invaluable service on many levels, and with the help of all those I have talked with in the past four months, now more than ever, I know that the trajectory remains.

88

THIS MONKEY'S GONE TO HEAVEN & IF THE DEVIL IS SIX THEN GOD IS SEVEN.

Against Anti-foundationalism

PART I

BY ELLIOTT EARLS

THE BLOOM IS OFF THE ROSE. Type design has lost its urgency, and has regained its soul. In the mid to late 90s I was working completely alone in a windowless studio, and traveling extensively. Routinely, I would find myself conducting workshops and lectures at American design schools. These alternating frames of solitude and activity left me with an uncanny feeling. It was as if I were watching time-lapse photography of the graphic design field in flux. This perspective, however warped, made it quite easy to put a finger on the pulse of design in America.

It seems as if there is always one idea or medium that is inescapable. Everywhere you turn, there it is. In the mid to late 90s, one of those ideas was type design. Type design was viewed as *the* shortcut to graphic design fame, and everybody wanted a piece of the action. Invariably, I obliged the students and would conduct a type design workshop.

Things have changed. No longer do designers lust for the quick buck and easy fame that a signature font will bestow. The reasons are legion and almost irrelevant. The more interesting question becomes: what did we learn from this episode? I learned that the craft of drawing by hand is still a most valuable asset when it comes to designing fonts, and that computer tricks are a poor substitute for intent. I know what I'm talking about because I was there, and I did inhale, happily indulging in the so-called typographic computer "experiments" of the 90s. I've come to acknowledge their shortcomings. Here's what I've learned.

IN AN ATTEMPT TO UNDERSTAND typographic form from a purely generative standpoint, I have developed my own simple taxonomy.

When an individual sets out upon the arduous journey of designing a typeface, I suggest that the generative formal impulse can be located in one of three areas: historical revival, vernacular interpretation, or exclusively formal extrapolation. While historical revival and vernacular interpretation are self-explanatory, the term "exclusively formal extrapolation" may need some elaboration.

When one is giving birth to a font not spawned directly from an existing model, what is needed most is the establishment of a biological discourse between looking and drawing – between retina and cortex. The Foundation Program at the School of Design in Basel, Switzerland placed clear emphasis on understanding form through drawing. It is in traditional figure drawing studio classes that one learns how to lock the movement of the retina to the movement of the hand. To be successful in this process, one learns that the mind must be quieted. The hand and retina must move in symbiotic lock step as they both trace the physical line. It's through this process that one can learn to trust not the mind, but the retina.

While making marks on paper, the internal non-linguistic dialog between retina and cortex may go something like this: How thick? How black? How thin? Thinner? Thicker! Bigger! Blacker! Whiter! Grayer? Closer? Farther! Tighter? Too tight!

I stress that this process, in order to be successful, is non-linguistic. The hand moves, the mark changes, and the eye responds. The eye, and how it relates to mark making, or more accurately, how it responds to the mark made, is the most important thing.

Letterforms are in large measure governed by social contract and simple optical principles, such as the ones preached by our now debased and debunked High Priest of Visual Thinking, Rudolf Arnheim. And while there are obviously far hipper and much more contemporary developments within cognitive science and perceptual psychology, issues of balance, harmony, scale, as well as principles of *gestalt*, all have a bearing on the function and legibility of letterforms.

As the letterform progresses through successive stages of development and refinement, the process becomes increasingly optical. When the impulse or the "idea" for a font springs primarily from optical phenomena, such as mark making, drawing, handwriting, or the manipulation of formal elements, it may be considered to have sprung from exclusively formal extrapolation. The resolution of a font, the successive development and refinement, is always an optical endeavor.

The simple process of making marks on paper is less of an intellectual process than a biological process. One must cultivate a feel for proportion, solidity, balance, etc. Excuse the digression, but when I talk about developing a feel, I know that some of you are rolling your eyes. Some of you may think that the term "feel" might be likened to the term "taste," with all of its class overtones and attendant critiques. Well, back the f..k up. I'm suggesting that one develops a feel not magically, or through attending the finest schools, but through rigorous application, and through working damn hard at acquiring a set of very concrete skills, then forgetting them. And what would those skills be to which one must dedicate him or herself only to eventually forget? Manipulative skills, first person, hand/eye-coordinated, flesh-based skills. What in jazz they call "chops," and in graphic design they call "fundamental graphic exercises"—line rhythms, gradation, and figure/ground studies.

MUSIC IS THE APPROPRIATE METAPHOR. In music, rigorous study of repertoire, theory, and physical application is what allows the musician the improvisational freedom to move the listener. Musical instrument performance represents the perfect synthesis of theory and practice. Theory is study understood and finally applied. But the essence is that theory (or thinking) is forgotten in the moment of performance. In the visual arts, as in music, it is important to follow a developmental trajectory that after diligent application ultimately includes not so much forgetting, as not paying active attention to these principles. You must trust yourself, and work by feel. Rely on the totality of your experience. Rely on your history to guide you. Think through the body. Arrive on the beautiful shores of naivete and anti-mastery only after toiling in the fields of mastery.

If at this point you feel the need to accuse me of anti-intellectualism, you'd be barking up the wrong tree. I'm an advocate of practice informed by theory and life. It's really a question of priorities and balance. And I'd like to be clear here. I am not suggesting that the type design process necessarily adheres to a strict taxonomic progression. And I'm certainly not an advocate of a rigid categorical approach to design of any form. Quite the contrary. It's my contention that the edge condition, the tension that exists in the gap, is where the action is. But for the designer interested in beginning to come to grips with letterform design, locating one's work within the three categories described

above is often helpful.

The question I am most often asked by students is some variation of the following: "Where do you begin? How do you get an idea or a concept for a typeface?" My answer is twofold. First, one should never use the term "concept" in same sentence as the word "typeface." Typefaces are not conceptual, they are formal.[1] Second, I tell them to study examples such as Zuzana Licko's Mrs Eaves, which is an excellent example of an historical revival; Christian Schwartz's Los Feliz, which is an excellent example of vernacular reinterpretation; and Frank Heine's Remedy, which is based on pure formal extrapolation.

But as they say, "God (or the Devil, or possibly both) is in the details." Quite possibly the biggest challenge facing type designers who are just starting out is that most can't see, nor can they draw (I should amend that slightly; most haven't looked, nor can they draw.)

Students who begin drawing typefaces must first learn to look at typefaces. I am often shocked and amazed at my students' first attempts to construct, for instance, the termination of a stroke. It usually involves a student using Fontographer. And when looking closely at the letterform, one often notices a complete lack of rigor, coupled with a hyper-kinetic line quality, which almost always leaves me with the impression that I'm teaching type design to a class of metamphetamine addicts. (Which I have found is usually not the case.) One need look no further than the plenitudinous offerings of foundries such as T-26 or Garage Fonts to find textbook examples of this undisciplined metamphetamine line.

There was a brief moment (December 1, 1991 through February 3, 1993 to be exact), when this approach to letterform design was culturally redeemable. Access to Fontographer enabled the designer, for better or worse, to cut the development time and cost of creating a font to almost nothing. The "Blend" menu in Fontographer would take two fonts and mathematically extrapolate, to produce a third new font. This process took seconds, and the results were fluid, kinetic, and seemed, from an historical perspective, refreshing. I'd like to also point out that in 1984, the hairdo worn by the front man for Flock of Seagulls, Mike Score, looked fluid, kinetic, and, from an historical perspective, refreshing. The letterforms produced in this way were a complete rejection of everything that type design represented to this point. And although this statement was desperately needed, it quickly became excruciatingly obvious that the baby had been thrown out

with the bath water. Students in design programs across America latched onto this methodology like Mike Tyson biting Evander Hollyfield's ear, and the results were about as culturally, intellectually and formally stimulating. On some levels it seems that the T-26 and Garage Fonts type catalogs are less type catalogs than exercises in cultural anthropology. They function best as an informal taxonomy of nearly every undergrad type design project ever initiated.[2]

I AM RESOLUTE IN MY BELIEF that there is simply no correlation between time and quality, and that all things historical are not necessarily bad. The geezers didn't get everything wrong. Although Modernism has become shorthand for dogmatic, imperious, doctrinaire, dry and anal, it is also rigorous, studied, quintessentially optimistic and highly formal. In a recent *Print* magazine article, Kathy McCoy encourages educators to abandon hand-based exercises in favor of the computer.[3] I would absolutely agree if it pertains to typographic skills for tracking, kerning, leading, comping, font selection, etc. I would completely disagree when it comes to the typographic skills of letterform design.

The ability to see, (no, to feel) the correlation between the ruling pen, nib, chisel and/or brush and the final letterform is essential. Does this imply that all letterforms must have serifs or strokes that are in some way informed by the ruling pen, nib, or chisel? Of course not! As a matter of fact, some of the most interesting typographic specimens bear no correlation to these tools. The great artist or designer is s/he who is no longer constricted by the rules. But anti-mastery comes after mastery.

Fontographer (the computer) is a great tool for some, but a terrible tool for the tenderfoot, the greenhorn, the neophyte, novice, rookie, or initiate. Fontographer has been a pox. It has spawned a plague upon the house of Montague. What is so inherently stifling about drawing on the computer? Tactility and nuance are the first casualties. Drawing with a mouse or a tablet is like driving a tank while looking through a drinking straw.

How do you design letterforms? Kick it old skool style. Draw them big, with a ruling pen and Plaka, and some Pro White. Focus on the serifs or the termination of the character. Don't so much understand how a letter is drawn: experience how a letter is drawn. Then refine the letterforms through successive redrawing. Sit back, evaluate them optically (with your retina). Then draw them again. Making them thin-

ner here and thicker there. Become intimately familiar with the French curve. Is it possible to achieve all of the above using only the computer? Of course, given sensitivity, discipline, and a true biological understanding of some of the preceding issues.

At this point, it would seem prudent to have a lengthy discussion about technical considerations. We should discuss what lead hardness to use in your drafting pencil or the benefits of vellum over plate bristol. I should provide you with a diagram on the proper method of loading a ruling pen with ink, and discuss how to successfully transfer your drawings into Fontographer. The nuance of these activities is critically important. But it's precisely because the nuance is so important that any discussion of them would be counterproductive. The gap between language and experience becomes a gaping hole as one begins to discuss issues of craft.

To borrow from our musical metaphor again, it's quite easy to rough out a plan of study for the guitar. It's quite easy for a guitar teacher to communicate to a student the technical aspects of any given musical passage. But it is nuance or "feel" that separates the chimps from the apes. And no guitar teacher or book or computer program can teach "feel." The nuance of the activity mirrors the nuance of the typographic form, which mirrors the nuance of a life. Gary Griffin, Metalsmith in Residence at Cranbrook Academy of Art, speaks eloquently about the "practice" of metalsmithing. He places emphasis on the literal definition of the word "practice": 1. To do or perform habitually or customarily. 2. To carry out in action; observe. 3. To do or perform repeatedly in order to acquire or polish a skill. It's all about craft. And craftsmanship demands practice. It is through the practice of type design that one will develop mastery and come to a deep understanding of all of the technical issues.

Walter Gropius was famous for his exhortation to his students in Weimar to "start from zero." It's when you invent the way a stroke terminates, or when you devise a new armature, that you can benefit most from traditional techniques. It's when you begin with the blank page of purely formal extrapolation that the old skool skills are most important. The geezers passed these methodologies down in a master/apprentice environment. Some of the skills, and I stress *some* of them, were not simply about reinforcing a professional caste system. Some of these skills are worth re-examining.

But craft is only one part of the equation. Next, I must deal with the

infinitely more difficult issue of exactly how one uses their craft to make work that moves the viewer. Which brings us to intent. We'll tackle that topic in Part II in *Emigre* #66.

1. It is almost completely without exception that I find discussing work in terms of a form/content dichotomy extremely counterproductive. I vehemently reject almost any attempt to discuss one as if it is not inextricably fused to the other. Style is ideological. And yet here is the exception to the rule; it is my firm belief that letterform design is about functional formalism to the exclusion of this thing we often refer to as "content." Do I contradict myself? Very well then, I contradict myself ("I am large, I contain multitudes." — Walt Whitman).

2. "Wait!" I hear you say. "Aren't you, Elliott Earls, the designer responsible for archetypical typographic examples of the metamphetamine line? Didn't you design Blue Eyeshadow, Subluxation Perma, Dysphasia, and Mothra Paralax? Isn't this a simple case of the pot calling the kettle black?" To which I say: "Yes and no." If we look at Blue Eyeshadow, for instance, it's important to first point out the origin of the name. For to name it is to claim it. In the late 1980s, when I was an aspiring high school Scottish soccer hooligan, living in that midwestern cultural hotbed and bastion of radical liberalism, Cincinnati, Ohio, I wore a mullet. Needless to say, in 1984, in Ohio, we wore mullets without a hint of irony. We thought we were tough and "new wave," and we thought the chicks would dig it. Yeah, the chicks. It was all about the girlies. And let me assure you, they had an equally distorted and perverse interpersonal aesthetic. It was the 80s. We were young, upper middle class, ultraconservative Catholic boys and girls and we had a paucity of suitably fashionable role models. The guys had mullets or "boy hair," and the girls wore tons of foundation, white lipstick, and blue eyeshadow. I should point out that these young women wore heavy blue eyeshadow regardless of their complexion or eye color. Because at that historical moment it was an established scientific fact that if one wore enough blue eyeshadow, the eye would look blue! Now, even at the tender age of sixteen, before my acquaintance with Josef Albers or color theory, this seemed all wrong. Even then, I often found my gaze transfixed, nay locked, upon the upper eyelid of a typical brunette with brown eyes. Something was horribly wrong here! The clash of color. The slavish adherence to dress code at the obvious expense of personal dignity. The spurious and questionable folklore or "weird science" underpinning it all. The font Blue Eyeshadow is in large measure irony. It was meant as a critique. It was a statement about the 1993 mid-cult typographic world on the verge of metamorphosis. It was a reflection on all the horrible emerging grad school typographic cliches *before* they made their slow death spiral into the mainstream, and subsequently onto your tray liner at Taco Bell. Blue Eyeshadow was (and is) a funeral dirge, a death rattle. Does that make it superior in kind to the aforementioned aborted undergrad type projects? You be the judge.

3. *Print*, LEARNING CURVES, Katherine McCoy, VOL. 57, no. 1 (2003), p. 30, 124-5.

Elliott Earls is a designer and performance artist. He is currently head of the Graduate Graphic Design Program and Designer in Residence at Cranbrook Academy of Art.

96

Legible?

Foreword

WITHIN THE WORLD OF TYPEFACE DESIGN there are few practitioners who have the ability to discuss issues of readability and legibility with a broad view towards the usage of typefaces. The profession of type design is a specialization, and too often its practitioners discuss the finer points of their efforts as if type exists in a vacuum. While there is much to be said for the purists and traditionalists who strive to uphold the beauty of ancient letter forms, and who continue to look for ways to maintain the look and feel established during the golden years of letterpress printing, too often they ignore the changing circumstances of design and the reading habits of their contemporary audiences. It's not that their claims are no longer valid; they're simply not the only way to arrive at effective forms of communication. Plus, there's more to graphic design than book design (which is concerned with specific typographic issues such as space economy and speed-reading), an area where most type purists tend to live.

But there are exceptions. There are type designers who both practice type design with all the knowledge and respect for its tradition and also keep an eye on its future and the ever changing, multifaceted environment in which typefaces are used, and who are graphic designers as well. Gerard Unger is one of them.

In 1992 *Emigre* published an article by Dutch designer Gerard Unger titled LEGIBLE? The article was a breath of fresh air, debunking many of the claims by type purists regarding people's reading habits, and leaving much room for design to be more than a "transparent" holder for texts.

At the time we published this article, *Emigre* stood firmly positioned at the opposite end to the traditionalists, and was obsessed with the notion that how type was used was more important than the faces themselves. In addition, we gave tremendous credit to the readers' ability to decipher just about any layout. Sure, what mattered was the

written content, but form provided content, too, and was meant to attract, engage, and differentiate.

There was another idea that set Emigre apart from the purists. We were interested in visual communication addressed at specific, small audiences (and small clients) with interests similar to ours. It was a reaction to the ideas of mass marketing, lowest common denominators, globalization, and universal standards of communication.

All of these ideas added up to experiments with layouts and typography that often went far beyond common sense. *Emigre* was a magazine about experimental graphic design, so we felt justified. It all backfired when these ideas were lifted indiscriminately and were appropriated for mainstream usage. The ideas then became easy targets for the critics who dismissed the work as being too self-expressive and illegible.

And often the critics were right.

Looking back at some of these issues of *Emigre*, I now realize how this youthful exuberance may have obscured some wonderful writing. One such item was Gerard Unger's article LEGIBLE? which was published in *Emigre* No. 23. As some kind of ironic comment on the title, I set the entire article in all small caps! As if I were trying to prove what we already know: that all caps text is difficult to read. Not only that; the small caps were slightly tracked and the text was set center axis. All big no-nos in basic text typography. Later, I felt bad about this. So in early 2003, 11 years after the fact, I wrote Gerard Unger to apologize. I told him I didn't remember what my justification was for setting his entire article in all caps. "Sure," I wrote, "*Emigre* was, and is, a platform for typographic experimentation and all that, but you don't really need an experiment to know that using all caps when setting a long text is not a very good idea. I'm sure both Gerrit Noordzij and Jacques Jansen, two of my teachers at the Royal Academy of Art in The Hague, and you, must have thought I had gone insane. Too much California perhaps. But you were kind, and never mentioned anything."

"About the article," Unger wrote back, "despite the caps, many have read it and discussed it with me." This made me feel a little better. But obviously, his article had withstood the test of time much better than my layout. Which is why we are reprinting it here in a different form.

After Unger's kind reply, I reread the original all caps article, and found it was actually not that difficult to read. Maybe it's not a matter of difficulty, but a matter of difference. Reading this old issue of *Emigre* transported me to another time. The odd layout, the curious type experiment, the physical qualities of the awkward oversized format, the smell of old paper, all these non type-related issues influence the reading experience, and not necessarily negatively. Sure, the speed and ease with which you can read this text is somewhat sabotaged, but this is replaced by a different kind of experience, one that makes reading the text perhaps more intense and therefore more memorable. Unless, of course, you're a type purist. But most people don't suffer from such fixations.

RVDL

REGARDING THE TITLE: this article was translated from Dutch, a language that does not have different words for "legible" and "readable." Both translate into "leesbaar." Upon hindsight, "Readable?" may have been the more appropriate translation for the title, and for some instances where the word is used in the text. But when this article was published, in 1992, "legibility" was the commonly used term for anything relating to the level of ease or difficulty of reading a certain typeface.

Since then, the words "legible" and "readable" have started to be used more deliberately within typography and type design discussions. "Legibility" refers to the distinguishing features of the individual letterforms; "readability" refers to how well letters can be read when strung together into words and sentences. For the sake of authenticity, the article was left unchanged.

Legible?

by Gerard Unger

This article was first printed in *Emigre* No.23, 1992

Suddenly legibility is under siege. While printed text, just like God, has been declared dead a few times, legibility, until recently, was still considered sacred. However, during the past few years, many doubts have surfaced. In trade magazines, panel discussions, and in the hallowed halls of graphic design, new interpretations of legibility are being considered. Wim Crouwel (graphic designer and former director of the Museum Boymans-van Beuningen) was recently quoted as saying that everything we knew about legibility twenty years ago is now invalid because the notion of legibility has been stretched so much since that time. We are inundated with so many different texts in such varied manifestations that we have become used to everything and can read anything without difficulty.

In *Eye* No. 3 (May 1991), Michele-Anne Dauppe suggests that legibility relied on set rules and could be measured against absolute standards that were obtained through optical research. Those rules no longer apply, she believes. The standards are shifting and legibility is pushed to extremes. Two issues of *Emigre* magazine (no. 15, 1991 and no. 18, 1991) contribute to this discussion. In Issue No. 15, Jeffery Keedy states that too many people strive to omit ambiguity (which is exactly what good, legible, typography aims at). Keedy believes that life is full of ambiguity, which is what makes it interesting. His typefaces emphasize this belief.

In that same issue Zuzana Licko proclaims "You read best what you read most." She hopes that her typefaces will eventually be as legible and easy to read as Times New Roman is today. She also states that letters are not inherently legible but become more legible through repeated usage, and that "legibility is a

dynamic process." In issue No. 18, Phil Baines fully agrees
with these statements and goes one step further when he adds
that "the Bauhaus mistook legibility for communication." There
seems to be a general consensus that the ultimate legible typog-
raphy is extremely dull. It overshoots the mark because no
one feels invited to read it.

PRINTED TEXT IS FAR FROM BEING DEAD. On the contrary, every
day more and more text is being produced on paper. But don't
we have to be concerned with its legibility anymore? It is
possible that the existing rules are too strict. How about those
rules that Michele-Anne Dauppe believes were established
through research? Who performed these tests and where can
we find the results?

In the book *The Visible Word*, published in 1968, Herbert
Spencer presents a summary of over a hundred years' worth of
investigations of legibility. The conclusions in this book are very
general, such as: "Words typeset in upper case are considerably
less legible than words set in lower case. Italics are also less legi-
ble and bold type can work, provided the inner spaces of the let-
ters are clearly visible. Medium bold is very legible. Many
readers prefer a text set in medium bold." The last chapter
of this book shows attempts at creating completely new letter
shapes.

Since 1968 several additional investigations have been per-
formed, but the results have added little to what Spencer had
already scraped together. They offer no shocking conclusions
that would lead designers to permanently renounce certain type-
faces or to accept one particular typographic arrangement as the
only correct one. The rules that Michele-Anne Dauppe refers
to, in fact, do not exist.

Yet rules for legibility continue to proliferate. For instance,
efforts have been made to establish sans serifs as the only truly
legible letters, or, simultaneously, to declare them entirely illegi-
ble. Spencer describes how scientists have researched this prob-
lem and have come to the conclusion that sans serifs, under

certain circumstances, are less legible than letters with serifs (BURT, 1959). Yet a few years later, some other scientists conclude that there is no significant difference between reading sans serifs or serifs (TINKER, 1963, CHEETHAM AND GRIMBLY, 1964).

WHERE CAN WE FIND those fierce opponents of serifs and sans serifs? Here we have some clear statements: "Of all available typefaces, the so-called 'Grotesque' [...] is the only one that spiritually fits our time." And: "The best experience I have had was with the so-called 'Normal Akzidenz Grotesk,' which generates a quiet and easily legible image." They are by Jan Tschichold from *Die Neue Typographie* published in 1928. In this beautiful book, he shows how developments in typography are connected with those in the arts, such as Suprematism, Neoplasticism and Dada. Tschichold was searching for a typeface for the modern age and sans serifs fit the bill. And just like many other graphic designers, whose ideas he represented and developed, he made a case to set text in lower case only. In 1929 he designed a typeface with mixed upper and lower case letters.

As early as 1925, Tschichold had written down ideas about new typography in an essay titled ELEMENTARY TYPOGRAPHY. Here he suggested using a sans serif as a matching elementary typeface. But he was still qualifying his viewpoint by stating that typefaces with serifs were better for use in longer texts. It was also his opinion that as long as there were no good sans serifs available, it was better to use a neutral font with serifs, which is what he did for this 1925 text. Three years later, those ambiguous statements had disappeared. The ideal sans serif was not there yet—although Paul Renner's Futura was a step in the right direction—and no mention of serifs was heard again.

During those three years, between 1925 and 1928, Tschichold had not performed any scientific research that forced him to adjust his opinion of 1925. His preference for sans serifs, and his opinion that they were quite legible and more legible than typefaces with serifs, were based upon emotional considerations. They were based on the desire to be modern, and in 1928

Tschichold must have felt more modern and more certain of his opinions than in 1925.

In that respect, nothing has changed. The recent pronouncements about legibility are still primarily based upon emotion and are prompted by the need for change.

WHY QUOTE TSCHICHOLD SO EXTENSIVELY? More quotes will follow, not only by Tschichold, but also by Stanley Morison. I do this because the texts of Tschichold and Morison come closest to a serious theory about our profession. There are other authors who have published theories on typography, but those by Tschichold and Morison have had the most visible influence on our profession.

Books on graphic design are often filled with practical knowledge acquired through hundreds of years of experience, with rules developed through intense observation and a deliberate use of typographic means. There are rules for preferable line length, letter size and line spacing, for the arrangement of the page, the use of initial caps, footnotes, etc. Yet a deeper, underlying theory supporting these customs hardly exists. The best these theories can offer is that clarity and readability are the highest goals, which means that the typographer should remain invisible.

It is curious that both the supporters and opponents of traditional typography held on to these basic goals. Tschichold mentions *Klarheit* (clarity) as the highest goal in 1928 and Morison wishes for "consummate reticence" in 1930.

Publishers, typographers, printers, and users have, since the days of Gutenberg, agreed within reasonable limits on what is considered legible. Anybody who consults a historical collection of books will quickly realize that those limits allow the designer quite some room—much variation can be detected.

Due to rapid and drastic changes that took place during the beginning of this century (and not just in the fine and applied arts), traditionalists and innovators alike dug themselves in and the previous voluntary agreements were replaced by strict rules, dogmas, and slogans. Against what or whom do those who

demand change today direct themselves? The only thing that seems necessary is to use those agreements again in a reasonable and relaxed manner. In numerous typographic works, the concern with legibility is taken with a grain of salt. There seems to be more freedom than in the 17th, 18th, or 19th century.

IN 1948, THE SAME JAN TSCHICHOLD who was quoted above, wrote in an essay titled TON IN DES TOPFERS HAND (Clay in the Potter's Hand); "Personal typography is faulty typography. Only beginners and fools will pursue it. [...] As typography addresses everyone, it leaves no room for revolutionary change. We cannot even fundamentally change one single letterform without destroying the typeset representation of our language and rendering it useless. Comfortable legibility is the supreme canon of all typography." With that, he radically denies his previous point of view. Tschichold was not the same typographer anymore. After a rough encounter in 1933 in Munich with the emergence of Nazism, he escaped to Switzerland and also moved away from his ideas published in *Die Neue Typographie*. Those ideas suddenly appeared too dictatorial and too closely resembled Nazi ideals, he thought. It is not without significance that he wrote the 1948 essay in London, because some of the ideas closely resemble Stanley Morison's, whose text *First Principles of Typography* had appeared in 1930. This publication quickly became very influential, particularly among book designers. "Typography is the efficient means to an essentially utilitarian and only accidentally aesthetic end, for enjoyment of patterns is rarely the reader's chief aim. Therefore, any disposition of printing material which, whatever the intention, has the effect of coming between author and reader is wrong. It follows that in the printing of books meant to be read there is little room for 'bright' typography. Even dullness and monotony in the typesetting are far less vicious to a reader than typographical eccentricity or pleasantry." Another lengthy quote from Morison: "It is no longer possible, as it was in the infancy of the craft, to persuade society into the acceptance of strongly marked and

highly individualistic types—because literate society is so much greater in mass and correspondingly slower in movement. The good type designer knows that, for a new font to be successful, it has to be so good that only few recognize its novelty. If readers do not notice the consummate reticence and rare discipline of a new type, it is probably a good letter." Here convention is required to go down on its knees. If these rules had been applied, then the profession would not have changed its appearance since 1930. However, the path didn't run this narrow.

IN *Typ* G, PUBLISHED IN JUNE 1991, Max Kisman writes: "The institution of the letter will be abolished. The power will be defeated. Since their digital manifestation, letters have been outlawed. The prevailing conceptions have lost their value. Graphic design is a fake and aesthetic-based page filler. Graphic design and typography will be banned." He adds: "The printed message is old-fashioned and of the past." We will forgive him this latter nonsense. However, I do agree with Kisman that there is frequent evidence of superficiality and that much design only draws attention to the work of the designer—narcissistic design without respect for either the authors or readers. Are those striking new typefaces produced to offer the readers more pleasure or to impress fellow graphic designers?

Kisman suggests, as a last convulsion of graphic design, "...to mix all design styles during a wild party in order to lay to rest the profession. So that with the resulting hangover, we can position ourselves to start the restoration."

Before the party begins, I want to know where the restoration is going to come from. How do we find out what legibility really is? To break with the past does not solve anything. It isn't possible; this is what even the most powerful revolution has taught us. By gratuitously repeating historical standpoints, the discussion is not served well, either. To live for the here-and-now and fun of it all, without concern for serious depth, as *Typ* G suggests, is oppressively restrictive.

I chose to once again carefully re-examine what reading essen-

tially is. The following observation is not complete by a long shot, but is my starting point for a broad and detailed reflection of legibility.

Disappearing letters

A MAN IS READING IN A BAR IN MADRID. We have just entered after looking around to find a nice place to eat. From the loudspeakers come shrill singing and the sound of trumpets. We don't feel like leaving and searching for another place. The restaurant is well occupied and at the table next to us there is loud debating with wild gestures. Strong scents come from the kitchen. All the senses are activated.

The man sits reading at the bar while absentmindedly cracking nuts. He has a short beard, sits on the stool with one foot positioned on the floor. He is reading a book. I order a drink at the bar and try, inconspicuously, to find out what he is reading. It is a translation of Hemingway. Next to him, glasses are being washed and filled. He quickly looks around from across his reading glasses and then reads on.

THE CULTURAL PHILOSOPHER George Steiner presented a lecture in early 1990 about the future of reading. He limited himself to books and classical literature in particular. Silence, he believes, is one of the most important conditions for careful reading. And silence is a disappearing cultural commodity. There is even a growing need for noise out of fear of loneliness, according to Steiner.

He is not the only person subscribing to such a pessimistic view. For many, the decline in book sales implies that it is not going well with reading. At high schools, the interest in literature is dwindling and more and more we hear about increasing illiteracy. Commercial television makes it even worse and there are many more influences that could turn reading into a threatened human activity. In all truthfulness, we know very little

about reading, which is why unfounded opinions can easily catch on. It is important to know how reading functions because it is still the way to acquire knowledge, and printed text is still the most used medium for the storage and transfer of ideas.

Take silence. It is true that there are quite a few activities in which noise disturbs concentration and limits people in their pursuits. However, reading is not one of them—certainly not to the degree that Steiner fears. Whenever a reader gets absorbed in the reading matter, the surroundings will quickly become less noticeable than the magazine, book, newspaper, or computer screen. The text becomes the world. The surroundings dissolve and with them will most outside signals. It becomes quiet around the reader.

Reading creates its own silence. I have often observed how, even in the midst of noise, someone who is reading and is spoken to does not reply until after repeated appeals. Fascinating writing pulls the reader in; the man in Madrid was a good example.

READING HAS BEEN EXTENSIVELY RESEARCHED. Eye movement, and the number of characters that can be taken in per move-ment, have been studied just as reading speed in relation to the amount of surveyed and remembered information. The in-fluences of paper color and lighting have been measured, as well as the time that someone can remain fully attentive while read-ing, and much more. The results of this type of research are interesting but offer a one-sided notion of what reading is; they give the impression that people read like machines, that you can turn on and off at will, and that reading is all about gathering dry information. Such research tells you little about the need to read and the pleasures and intimacy of reading. Also not touched upon is reading as a way to escape reality and to engulf yourself in other people's realities.

There are many different ways of reading, tied to rather varied reading objectives. You can read to research, read to study, read to be informed, or read to relax. Sometimes you look more than you read, sometimes you read just a bit, or with interruptions,

and then you read for a while again. Telephone directories and dictionaries you obviously read differently than the newspaper, and a novel, too, demands to be read in its own particular way.

With every form of reading, this silence arises. Most people don't realize this. And that's exactly it. That silence arises out of the concentration through which your consciousness is narrowed. You turn inward and surrender to reading. It is a semi-conscious or even subconscious action.

Simultaneously, with the silence that causes one to read, something else quite wonderful happens. Not only do the surroundings dissolve, but also the object on which your attention is focussed. The black, printed letters dissolve in your mind like an effervescent pill in a glass of water. For a short moment, all those black signs disappear off the stage, change their outfits and return as ideas, as representations, and sometimes even as real images. It doesn't matter whether the reading matter concerns news, literature, relaxation, or science. First your environment dissolves and next the reading object disappears; or at least, both are placed at a subconscious level. When this type of artistry succeeds, the contents of the text flow directly into the mind of the reader.

Although typographers would like to pride themselves on the logic and precision of their profession, it is in fact not so clear-cut. Typography seems exact because much of it has been done in the same way for so long. There are really only a few fundamentals that are set: we read from left to right and from top to bottom. Letter shapes and letter sizes are reasonably limited. But beyond that we rely primarily on emotion.

Common sense, experience, and practical limitations are what have regulated typography. The profession is founded on empiricism but leaves much room for interpretation. We don't have to keep up this facade of exactness. Typography and typefaces fare well by the acknowledgement that emotion plays an important role because it allows texts to be designed with more passion.

Wait a minute! This introduces a contradiction. I just ex-

plained that reading is a fantastic disappearing act, a double one at that, and now I start talking about designing with passion. Doesn't that imply that designers want to be noticed and that they produce striking or even flirtatious products? Together with this disappearing act, don't we need the often-praised invisible typography? This is a noble principle, derived from book typography, which preaches respect for both author and reader. Book typographers fulfill a subservient task that restrains them from manifesting themselves and positioning themselves between author and reader. Craftsmanship yes; artistry, no.

ACCORDING TO MORISON'S *First Principles of Typography*, this is the way to do it. Actually, the notion of invisible typography is best verbalized by Morison's friend Beatrice Warde, one of the few women who has written about typography, in an essay titled THE CRYSTAL GOBLET OR PRINTING SHOULD BE INVISIBLE (1932). Both texts offer crystal clear starting points guiding author, typographer, and reader back to the few essentials of reading.

According to this principle, beautiful "naked" books have been produced, without decoration, that are a pleasure to read. In the hands of a master typographer, with an excellent eye for proportion, this ascetic typography can render monumentally plain books—pure typography, pure text, realized with plenty of devotion and the finest materials. They are also very expensive books.

With the average mass-produced book, typographic simplicity is usually the result of forced restrictions instead of self-imposed restraint. That's why many of these books are typographically quite "undressed." Typography becomes a balance sheet. Typeface, type size, proportions and other elements are defined by the demand to fit the text on a limited number of pages of restricted size. The text is not allowed the space it ideally deserves. That's also why many of these books, particularly on the inside, have been designed decently at best, but usually look indifferent and cold. The covers are often designed conversely. As signposts for books, covers have become louder and more colorful. To the readers, it must be a strange experience after

some nicely spiced hot sauce to bite into sodden, cold rice.

It is particularly these typographic products that can use a little bit of warmth on their pages. Besides this, I have little to complain about. Newspapers, magazines, and other printed matter are usually designed with sufficient emotion, and more than sufficient on occasion. Restraint and invisibility are as good as absent. Yet here too, the double disappearing act succeeds. Loud newspaper and magazine page designs create their own silence and dissolve. Visible typography is read also. This leads one to believe that Morison's principles sound good but don't connect with reality. To find out if this conclusion is correct can be seen upon closer inspection of the most important typographic ingredient: the letter.

INVISIBLE TYPEFACES DO NOT EXIST. Nobody will choose a typeface that doesn't look like anything. Everybody I know who regularly uses typefaces does this with conviction and dedication, even with passion. Advocates of invisible typography, too, will get emotional when discussing their favorite typeface. The basic forms of typefaces remain uncomplicated. Not much can be changed. It is very simple: when we deviate from the basic shapes, reading becomes less easy. This is no problem for short texts or headlines, but in long texts its effect is unfavorable.

Let's stick with text faces because headline faces are there to be both seen and read. But for real reading, you need experienced text faces with conventional basic shapes. Not conventional typefaces, that's something entirely different! Only the basic shapes need to comply with what we are used to. To this conventional frame, the type designer applies the features that supply typefaces with their characteristics. Every designer has particular habits that ooze through into the typeface designs: typical curves and corners, idiosyncratic transitions from thick to thin, a personal approach to endings, a peculiar movement throughout all letters and elements. The ideas of the type designer are dipped in the styles of the times, which help define the characteristics of the letters.

Furthermore, there are influences of technology, such as the rough paper and thin ink of newspapers, and the fast turning printing presses that newspapers are printed on. Such technological influences make demands on typefaces that lead to pronounced characteristics—in this case, an entire category of typefaces better known as "news faces." Typefaces for use in books are generally a bit more refined due to less severe production circumstances.

Typefaces endow printed matter with a character. They turn newspapers into newspapers and books into books. Together with page layout, paper style, binding method and format, they turn a text into an individual product. As soon as the product is picked up and the reading starts, the attractiveness of the typeface will help the readers on their way. Briefly they show themselves and then they retreat.

For the designer of new typefaces, it is a challenge to create an exciting combination of familiar and unfamiliar elements. How far can the type designer go when the basic shapes are dressed up with little known, or even unseen, elements? Are the basic shapes perhaps open to some alterations? This is how two converse qualities are united within letter shapes: common sense and attractiveness. This latter characteristic does not function when invisible. One of the reasons why there is a constant demand for new typefaces is the fact that we get used to the peculiarities of older typefaces. What you see too often doesn't work anymore. This is how typefaces play their double role until we're fed up with them.

112

As always, we're curious to know what you think about *Emigre*. Send your comments to: editor@emigre.com or mail a letter to Emigre, 1678 Shattuck Ave. #307, Berkeley, CA 94709, USA.

THE READERS RESPOND

Dear Emigre,

As a designer, I grew up with *Emigre* as a source of inspiration and continued encouragement for my life as a designer. I followed *Emigre* as it changed formats. I began to appreciate reading about design as much as feasting on visual explorations.

However, *Emigre* has nothing to say to me now. I have been out of work for almost two years. Nothing could have prepared me for this vacuum and so far these articles are of little inspiration. If you've said anything relevant this last year, I have missed it.

I've worked in marketing design and the recent changes in the employment environment leave me wondering sometimes if I am missing the point of what the communicating business is about post-boom? Most of the time I'm just one resume of 500.

Before, if you were a designer who had a visual eye and could plan and get people excited about your ideas it was all good. Now, positions are so defined and competitive you're unqualified without InDesign, even with ten years of Quark. Ideas and enthusiasm seem like excess.

Later *Emigre*,

CHRISTIAN SIMON

Dear Emigre,

As much as I love it, I do tend to think most design writing these days is either self-congratulatory or individually/industry critical. More visual or psychological theory and exploration on this phenomenon that is modern graphic design, less talk of the Photoshop interface or how it sucks to show work to a group of corporate employees. Corporate and commercial cultures have been theorized plenty in the last 30-40 years under the genre of social philosophy. Upon reading almost any primary Post-modern theory, it becomes clear that the expansion and introduction of new visual media and communication techniques have been the inspirational departing point for many of these writers. The visual environment needed explaining but a confused explanation it got.

Most graphic design is unfortunately very temporary, whereas most buildings and art (genres) stand through decades at the very least. The graphic design that stands the test of time usually sticks around because it functions. When graphic design works on this level it is quickly assimilated into the surrounding culture; the map of the London underground system for example.

Unnoticed as either art or architecture but merely used, graphic design floats somewhere between these two disciplines as communicator of the immediate culture to the immediate culture, and I think that becomes its problem of (non)respectability as a creative movement or need. When graphic design does not work anymore, however beautiful looking, it is replaced and relegated to the portfolio of its creator. Graphic design is art in the wrong context. It does not take the highbrow route of explaining or defining a state or environment, as art and architecture do. Graphic design does not make the statement; it gives a visual signifier to a client's statement. Graphic design makes changes on other movements' behalf. It is primarily important but ultimately secondary.

Graphic design is ultimately a service, but the visualization of a culture's needs or desires is a necessity. It is this necessity that needs the theory. We are defined by what we see. What we see in front of us creates the patterns of our lives. By exploring the visual and psychological relationship of our surroundings, we will find meanings yet untold of our behavior and purpose, and graphic design is the perfect way to explain what we find.

YOGI PROCTOR

Dear Emigre,

Picasso said something about how the computer isn't so wonderful because it can only answer questions but cannot ask them. Design is a bit like this. While it can provoke questions, it is generally in the business of answering them. Other fields ask the questions, the very questions that generate movements like Modernism and Post-modernism. Design eats the fruit of this questioning. And its teeth and stomach are design criticism and design theory. Design needs both the food and the digestion in order to keep living, as well as to keep providing answers, to keep solving problems. So an organ like "Rant" is a fine thing and a great help.

However, it is probably not enough to look into the world of graphic design and wonder where it is going and what it should be doing. We'll

probably need to hear from artists and writers and philosophers and psychologists, perhaps even scientists, before we begin to have a good sense of where we stand and in which direction we might be heading.

TRENT WILLIAMS

Dear Emigre,

I like your magazine. I've never had a subscription but whenever I see *Emigre* I always buy it. I don't know too much about graphic design or typography. I'm learning, and your magazine thing is a big help.

So I recently purchased (and read) no. 64. At first I was like, "Hey this is what I've been trying to say." Except for me it's architecture. I see a lot of crap all over the place and it seems like it keeps piling up higher and higher and everyone is full of themselves and is sooo cool and shit, that, well, basically, I just want to puke. And then they pull in all that theory crap like Deleuze and Guttari, or whatever their names are, and at this point I think about becoming a garbage collector.

I guess the point is that I was thinking about how you were saying that "design styles are largely concerned with how things look" and I was like "Yeah! man, that sucks," how it's all about that. But then I read the rest of the issue and I was thinking more and more that that's not the problem. It's design that is the problem. Or the focus on design and being designers. The idea that we should be designers, or that the world really needs another designer is wrong. And it's a trap.

We can't confuse creation/invention/problem solving with expression. We need to have a clear idea of what each of these things mean. And when they are necessary and appropriate.

So the dictionary says that "design" means conceiving or creating and a whole bunch of other things, but my etymology dictionary says it derives from the Latin "designare" which means to mark out, devise. Think of the word designate. Maybe Designers should call themselves Designators.

Charlotte Perriand was an architect and furniture designer. Anyway, she once said that if there is a problem to be solved, she has enormous creative energy, but if there is no problem to be solved, she is incapable of conceiving anything.

So basically I think the whole big problem with everything is that no one is concerned with solving a problem. Even more importantly, no one is even concerned about stating the problem. Yeah, I know, this is basically what Le Corbusier said. But I think he's right.

After stating the problem we can focus on the expression of the solution. Sometimes just stating the solution is enough.

Sincerely,

MARC BAILLARGEON

Dear Emigre,

Thank you for "Rant," which I trust and hope will stimulate a more meaningful design discourse. We will remain peripheral to the evolution of culture, however, until we demonstrate, through our actions as well as our words, the simple, human power of design and banish the quaint notion of design heroes to our mythological past. Ultimately, a broader range of voices must be engaged and a new professional framework created, neither of which are likely to happen through our existing forums and institutions.

Deepest gratitude for encouraging the iconoclasts and supporting the idea of change.

ROB DEWEY

Dear Emigre,

Emigre #64 was a blockbuster issue. I could tell that the opinions were honest by the cranky subtext in each article. It's hard not to be ornery when you're critical. The nice thing is that they all help make graphic design a stronger and more confident activity. Thank you, *Emigre*.

Mr. Keedy's piece stands out for me. He's becoming the Michael Moore of graphic design (we should be so lucky). But I feel that Mr. Keedy has over-generalized and blurred some distinctions, like Moore does with his documentaries. Forgivable, but, regardless, here is what I noticed: Mr. Keedy wrote of a quick return to Modernism by designers who have abandoned the complications of Postmodernism. The problem with this concept is that if you think of it the other way around, then those same designers might in fact be recontextualizing styles mined from Modernism. The past is the past, even the recent past, so the process of looking back to move forward, or even sideways, is still in keeping with the spirit of Postmodernism. Maybe his Modernism 8.0 is actually Postmodernism 1.1.

Another blur is the idea that designers can return to Modernism. They can't, because it ended in 1945. The Nazis made derelict any strivings the world could stomach for truths, universals, "timeless" strivings and the like. Not that it didn't continue through the end of the 40s and

on through the 50s and even 60s, but it was just residue. We can't be Modernists anymore, but we can mimic one of its symptoms, the International Style. This gets me to my last problem with his article.

There's an over-generalization taking place when Mr. Keedy calls the clean design we see around today "Modernist design." Maybe the particular variety he is describing should be termed "International Style in the Swiss tradition of Late Modernism." Okay, it's too long. But the shorter "Modernist design" is just too broad.

Eventually Modernism and its progeny will wear thin on design clients, too. Recently, my company Worksight had a project with a marketing manager at MoMA who said she wanted something "timeless." I suggested that the best we could do was "enduring." That worked for her as well.

SCOTT SANTORO

Dear Emigre,

I decided three years ago, after graduating from university and holding a number of jobs in the publishing industry, to return to school and study design. My previous education was a BA in Semiotic and Communication Theory and Art History, which served well in the world of academia, but does not, as any parent will tell you, "fill your stomach," despite what it does for your soul. As an editorial and publishing assistant at an art magazine, I realized that editorial design would offer the best of both worlds; a place for abstract thinking that is necessary in art making, and the come-home-to meal that would invariably contain the meat aspect of the diet, which was missing before. This was in 2000. The market had already slowed down and disaster was yet to come. There was no better time to become a student. However, the next few years proved to be a struggle unto its own.

Classes teemed with students desperate to intern, or job-shadow with their desired mentors on a part-time basis or during summer break. The agencies caught wind of this and started offering students paid positions severely scaled down from professional standards. Other hopefuls, who felt defeated by the limited opportunities, decided to bargain their way in, ousting their peers from low-paying jobs to settle for even less-paying jobs, until the work became mere charity. The underbidding should have acted as a caveat to the design community — like the illustrators who sold themselves out (and hence their profession) by distributing their work as clip art on CD ROMs. Underbidding

became the industry's standard, with some agencies and studios convincing themselves they were providing educational programs.

Nothing could be farther from the truth. The students who couldn't find work threw themselves completely into school, thinking that the investment made to this end would somehow compensate for the lack of practical work experience. Except, somewhere between learning the ropes and climbing the ropes, things changed. Uncertainty loomed. Students became anxious at the prospect of designing direct mail inserts for banks and calendars for realtors instead of the Carson-esque type posters and flip book projects they'd spent months perfecting.

Suddenly there are two grades of design: 1) everything we want to do and, 2) nothing we could care to touch. And since a lot of what is out there is 2 (with 1 usually reserved for the currently hot agency), some of us ended up opting for 3; leave school and start your own small studio.

I had considered door number three a few years ago, but never had the courage to abandon it for the occasional secure-meals-prepared-by-mom-always-including-meat student way-of-life.

Was it time to reevaluate? No. Was it time to initiate? Yes. And 2003 happened to be the right amount of time to reflect on all these options (3 years, 3 choices?) and start making what apparently the design community feels is diminishing: smart visual communication based on strong conceptual thinking.

Who are we? For lack of a better word, we are the independents. We launch our portfolios on the web at night while we wait tables during the day. We spend our after-hours writing press releases and business proposals after spending long hours temping at big impressive offices. And you can always catch us in the freezer section of the grocery store eyeing tofu like it was a rib-eye steak.

Since our means are limited, we are pressed to resolve problems in unconventional ways. We make buttons, stickers, t-shirts. We contribute to zines, drum up our own art shows, and collaborate with others in creating opportunities to produce event identities. Our best work is the weekly comics, or posters you see on the streets, on telephone poles, construction sites, announcing events like independent bands, art shows or club listings. We do all this hoping that in our own small way we can have a large impact. That we can one day stop being graphic designers (or as I would prefer, graphic thinkers) at leisure, and be graphic thinkers at large.

To blame being unemployed on the tough economic times is to

address only part of the problem. I believe the other contributing factor is a complete lack of interest in intelligent visual communication, and that as thinkers we are content in accepting these times and keeping quiet. That we have nothing to say unless we are speaking for someone else. That our voice isn't worth hearing unless it is called into action and mediated by a client who, undoubtedly, in this economy, wants change without changing. Who are we kidding?

The sad thing is, that this introverted attitude has now somehow affected the one place that in the past was critical in providing a place to finding one's voice: school. Teachers and students tiptoe around when it comes to critiquing work. Style over substance becomes the dominating aesthetic. Rebellion has vanished.

And I will now come to the point I have taken great pains to contextualize.

For those of you who are shifting gears, paring down, and looking back to determine the next step, I have a suggestion: consider sharing your knowledge and experiences in an educational capacity. Teach. Publish. Show. Lecture. Invite other like-minded and not so like-minded individuals to question, argue, and encourage your views, thoughts and feelings. As visual thinkers, we should never forget that our main objective is communication. That the world needs just as much *Adbusters* as it does advertisements. And if it may seem that doors are closing for the time being, it is our duty to exercise our ideas, embracing all levels and means of communication, so as to be ready when things comparably resume to as they once were. To all practicing individuals involved: your experiences, your wisdom, your perspective, your vision, is invaluable. Let's discuss it over dinner.

NATALIE SHAHINIAN

Dear Emigre,

I was quite amused by your latest issue. How totally rebarbative to most graphic designers today who barely read books anymore. No picture in sight – just text and meaning.

I hear you! Graphic design is in a sorry state. It used to be bubbling over. Now it just seems to spurt.

What is the problem? I have one thing to say: Money.

The need to sell has completely changed graphic design. It has now become a tool for selling; selling products, ideas, all pre-manufactured and pre-digested for our consumer-driven society. Yes, we have now

become just another tool that companies use to sell their products and services.

The need of our clients to sell at all costs has driven many of us to create things that do not disturb or challenge the *status quo*. Why would you want to challenge it since it pays your bills? Why scare people with concepts when all they want is the bottom line?

All of the revolution of the 90s in which Emigre took part has now, sadly, been assimilated by any designer who can work a computer and wants to be edgy and avant-garde, but in the end, is just plain bland; zero calories, fat-free. It has become an idiom and all the meaning behind it has been removed — the style assimilated to sell funky, edgy products to as many people as possible who think they are edgy and funky. Thanks to an image-driven society, style has replaced substance since it's easier, less time-consuming and easier on the brain.

What a monster has been created!

ADAM BILINSKI

Dear Emigre,
Congratulations on Issue #64 and the return to dialog-driven content. It is nice to read the thoughts offered by the various authors, the work of Kenneth FitzGerald and Shawn Wolfe is especially strong.

When I saw that Rick Valicenti was a contributor to an issue purporting "…to challenge today's young designers to develop a critical attitude toward their own work and the design scene in general," I looked forward to his perspective, knowing him to be an engaging and insightful man (we had a one-on-one discussion after his presentation in Portland a few years back). Unfortunately, I was left in total confusion as to his motives or intent and instead found *Cranky* to be a pitiful display of arrogance that made me so embarrassed I couldn't finish it. I don't care what Rick believes his stature in American design history to be — *Cranky* is utterly stupid.

Please forgive me for accentuating the negative, but I hold *Emigre* in high regard and hate to see it stoop to such levels because of an author's "stature." Please encourage Rick to read FitzGerald's *Quietude* before his next submission.

MIKE KIPPENHAN

Dear Emigre,
I just finished reading *Emigre* #64 "Rant." It was scary reading because

you were describing exactly what I've been going through professionally for the past year. Thanks. I mean really thank you (if it was possible to hug by email I would). You have saved me from months, perhaps years of mental stuggle.

GARRY TRINH

Dear Emigre,
While I really enjoyed the genuine aerial rant performed on the pages of *Emigre* #64 by Rick Valicenti (equal parts astonishment and self-loathing?), I felt that Jeffrey Keedy's ongoing misery with re-defining "Modernism" to fit his own agenda definitely provided me with something to debate. I've thought about writing in to you about his pieces before, just to ask from where on earth he dredges up such a narrow and misanthropic view of Modernism. From what I've read and figured out, one ought to credit the purveyors of Modernism with both a bit more naivete and a lot more generosity of spirit than Jeffrey Keedy's arguments will ever allow.

But the piece by Denise Gonzales Crisp, Kali Nikitas, and Louise Sandhaus takes the biscuit. Because if the aim of the article was "to challenge today's young designers to develop a critical attitude toward their own work and the design scene in general," then it missed by a long way. Three American academics yakking about their holiday and wondering why nobody asked them about their work does not a design discourse make.

In particular, I take exception to the sentence (attributed to Experimental Jet Set) that "…in Europe, Helvetica is just a typeface…" I mean, come on, guys, *what* does this mean? That Gonzales Crisp, Nikitas, and Sandhaus take this oxymoron as an indicator of the Jet Set's "awareness" strikes me as ludicrous. How could a howler like this get quoted out of context? Or rather, how could it hit the page and not be seen to need greater context than the authors provided?

So, talking of context, as we are all designers here talking to other designers about design, about cultural difference, about critical significance, etc., you can interpret this "Helvetica-doesn't-mean-what-it-might" thing a number of ways:

A. Of course it's just a typeface (as opposed to finger painting or braille). We set type with it.

B. Of course it's never just a typeface, least of all in Europe, because Helvetica is also "Swiss." That means "Swiss" in the Modernist, sans

serif, grid-based International Style. And as a typeface of choice for those who subscribe to that aesthetic, variously in use for the last forty years, it is a cultural signifier that most educated designers don't fail to recognize. At a glance Helvetica is mostly taken to mean "International Style Modernism of the 1960s and since," and it's still very popular with minimalists and functionalists of all stripes.

C. Of course it's just a typeface in Europe, because under American copyright law, only the name of the typeface can be protected. When the u.s. giants of publishing software went to war over font formats and rival licensing deals in the 1990s, the result gave the rest of the world default sans serifs like Swiss and Arial to use instead. Not unreasonably, it is claimed that both of these faces are cheap knock-offs of Helvetica. While this kind of nonsense is nothing new – the great thing about standards (like industry standard names for things, like typefaces) is that there always are so many of them. Prior to my needing a separate piece of software called the Bitstream Analog to tell me what the standard name had been changed to, Helvetica was only a standard name in the Linotype type library. However, these days, when the fonts are bundled with Microsoft system or browser software (85% of the pcs on the planet?), you have to figure that a lot of people out there think that Swiss, Arial, and Helvetica have nothing in common.

D. Of course it's never just a typeface, because Helvetica is arguably the most neutral, sterile, soulless, and "personality-free" typeface available to the designer. It is the freeze-dried instant mashed potato of the design kitchen – it's filling and it'll do in a hurry but it has no flavor and it's not very nutritious. As the joke goes, 500 years of Swiss neutrality brought us the William Tell Overture, the cuckoo clock and what…? So Helvetica's also a number of other things, even within Europe, even within the sans serif category, because everyone has their respective favorites. Maybe this should have been the point of discussion between Gonzales Crisp, Nikitas, and Sandhaus and the people in Europe whom they visited; we know that to actively choose Helvetica is NOT to choose Akzidenz Grotesk, Futura, Gill Sans, Avenir, Univers, Folio, Trade Gothic, Frutiger, Syntax, etc. or to engage the regional, temporal, or cultural significances that those faces might imply.

E. Of course it's just a typeface, just which one are you referring to? I think the "old" Helvetica comprises 19 or so variants, so which one(s) are the Jet Set using? The roman? The medium? The bold? The condensed? Unless of course they meant the sleeker 1980s re-cut called

"Helvetica Neue," or the Inserat version or the Rounded version and perhaps forgot to tell Gonzales Crisp, Nikitas, and Sandhaus – in which case a further 50-odd variants are possible. But this is possibly getting too technical – after all, they're only designers and academics.

F. Of course it's never just a typeface, because Helvetica is the most successful, ubiquitous typeface there ever was; widely available in all the older typesetting technologies, licensed around the world, adopted as the corporate face of countless big businesses, overused for decades. You could call it a monster, a miracle of modern marketing, rather than a typeface. And look at the reaction of (other European) designers. Erik Spiekermann's response to Helvetica was to suggest that it made everyone look the same, so he gave the world the much lovelier and more useful Meta instead. Neville Brody felt obliged to create Blur as a deconstruction of Helvetica and got quoted as saying "I hate Helvetica." Would these designers do what they did if Helvetica was "just a typeface"?

G. Of course it's just a typeface, but let's remember that Helvetica is the default typeface in Quark Xpress and certain other design software. This means that a conscious, practicing, and aware designer might choose to avoid using it at all costs – otherwise how is the client to know that his or her commission has been "designed" for real? Thus "designers" who use Helvetica in Europe or anywhere else run the risk of having their work labeled "unemotive," "banal," "naive," "ironic," or just plain "lazy." After all, as a default, this is the typeface one doesn't have to *think* about using. This is a particular problem in education. As Gonzales Crisp, Nikitas, and Sandhaus should know; students can be both lazy and/or timid in their choice of type – often they only emulate the "cool stuff" they see around them or they're afraid to use anything more psychologically revealing than the default.

H. Of course it's never just a typeface, because Helvetica is a form of visual bondage. The graphic design exercise whereby one briefs students "to produce outrageous, shocking, volatile, and emotionally charged type-only arrangements using any face they like as long as it's Helvetica" is a perennial favorite. Why is this a good exercise? Without the distracting choice of 50,000 typefaces, one might realize a whole bunch of other stuff; like understanding that a perfect neutral is a very hard thing to achieve, or that hard exercise is necessary to develop a real "taste" within the constraint of "vanilla" typography.

I. Of course it's just a typeface in Europe. Possibly the Experimental Jetset's T-shirts that sell on the Internet are explicitly *not* about the

typography – perhaps they're just about whether one recognizes four or five famous guys' names – and it's just another way of selling rock 'n' roll ephemera. Are we to admire the Jetset for having found a way of cashing in on the kudos of the Rolling Stones and the Beatles without having to pay anyone licensing, copyright, or royalty fees? Or are they doing us a service by suggesting (yet once more) that rock 'n' roll is big business?

In case anyone should think I'm some kind of Helvetophobe, I do admit a kind of grudging respect for it. It's never my typeface of choice, but I've had to use Helvetica on several occasions. In 1998 I was asked to lay out a book that the author and editor insisted was New Zealand's first "chemical novel" – a story about heroin abuse, among other things. I remember they rejected the really "whacked out" experimental designs that used Ray Gun Bold and Myriad Tilt as text faces in favor of Helvetica Neue Light, because for them using Helvetica signaled the *Trainspotting* look. Like the Jetset example, this was a case of a very straight corporate typeface being used to signify rock 'n' roll debauchery. As you Americans might say, go figure.

Kind regards,

BEN ARCHER

Dear Emigre,

Emigre 64 was promoted as a renewal of the journal's past commitment to theoretical content and ideas. To this end, the journal revisited past writers and asked them to comment on the current state of graphic design. I suppose critics, like typefaces and fashion, are subject to the distortions of repetition. And like other closed systems, two symptoms of inbreeding come to mind: first, the emergence of startlingly novel mutations, and second, the increasing lack of fitness of each successive generation. The authors had it half right: graphic design *writing* does suffer from an anemic lack of content, but in their lament over the state of graphic design, the authors reinforced a situation already at hand.

The most provocative – and disturbing – aspect of *Emigre* 64 is that while it claims to critically challenge the state of contemporary design, it essentially functions as a conventional "how to" style guide (pun intended). For graphic design to evolve a critical discourse, it must shift from a preoccupation with styles to questions of representation, agency, and human values. Much like Walter Benjamin's allegory of the difference between the practices of the magician and surgeon, critical writing

does not leave its object untouched: the surgeon's transformative ability manifests when she enters into her patient to reveal a new previously hidden perspective. Effective writing demands the same awareness of context: it cannot operate in a vacuum. Graphic design writing needs to develop its own techniques, procedures, and venues for theorizing its place in the world. Questions of style are an intellectual dead end.

In a parallel comparison, emerging architectural theory in the late 1960s began to challenge the impasse of a postwar architecture grown stagnant by a largely positivist functionalist doctrine and the leveling appetite of corporate commodification. By introducing the conceptual tools of other disciplines that had already cultivated sophisticated methods to evaluate discursive production, architecture was able to re-evaluate and re-invigorate its own theoretical output. Over the past thirty-odd years, by focusing on questions of being, cultural politics, and forms of representation, architecture effectively moved beyond journalism (read: "a discussion of style") to produce a solid body of critical insight, one that reflects architecture's formal, socio-cultural, and political domains. Graphic design offers similar opportunities for investigation. Design history — history in general — is a record of events, human struggles, and the recognition and recovery of individual and societal expression. It is not singly a succession of period styles as so many of *Emigre*'s established voices seem to perceive. Anthony Dunne and Fiona Raby are able to practice in RCA's Critical Design Unit precisely because an understanding of history has been established elsewhere. Granted, history classes should be more than a record of formal developments. They should also present a synchronic analysis of culture and society (one which expands discourse horizontally to place design in relation to literature, painting, politics, etc.), while unfolding a diachronic understanding of graphic design (one which evaluates formal development vertically through time). All of this requires a greater depth and breadth of understanding on the part of instructors and institutions. But institutions tend to reproduce themselves; if their own instructors and administrators are not equipped to provide a greater critical understanding of history and theory, how can one expect the same from design graduates? In fact, the most sought-after qualification of new hires at design institutions is past practical experience rather than the ability to evaluate and expand critical discourse in graphic design.

I applaud Kenneth FitzGerald for his courage in pointing a finger at

design programs. Too often, while the advertised academic job description states that "cross-disciplinary ability is desired," such ads in truth refer to applied mixed-media techniques of print, web, and motion graphics rather than the ability to introduce advanced art theory, literary criticism, cultural theory, or philosophy in the seminar classroom or design studio.*

Contrary to the neo-conservative nostalgia expressed in *Emigre* 64, Modernism has not disappeared, it has simply moved elsewhere – a fact not lost on my generation of designers. The historical avant-garde sought to reconcile the gap between technological production (civilization) and human expression (culture). To do this, they experimented with new forms believed to more accurately reflect the *neue sachlicheit* of industrialized production. A number of the authors fail to consider that it may not be possible to evaluate a contemporary Modernism on the basis of formal resemblance or operative analogies, given the radically changed state of practice since the 1920s or the introduction of desktop publishing, the web, and television, for that matter. Our technological revolution involves the computer, the Internet, and the video camera. Yet unlike the unornamented forms and rational geometries that the historical avant-garde emulated, contemporary technology has no obvious physical or visual analog; its labor is digital.

Generally speaking, one of the productivist aims of the historical avant-garde has been achieved: technology is infinitely available to society today. But at the same time, the dissemination of technology and the saturating effects of mass culture have eliminated disciplinary specificity and individual aesthetic experience. Even though authorship and self-expression were anathema for the historical avant-garde, they serve a potentially critical purpose today: authorship, or design signature, is a way for contemporary practices to imbue a work with quality. Despite the misplaced conceptions of design by social critics who dismiss the signature as a by-product of megalomania, the signature is in fact a form of critical resistance to the homogenizing and debasing forces of modern life. The irony of confusing a design signature with intellectually-devoid formalism, while selecting other firms as exemplars of content-driven work, is to mistakenly dismiss image for a lack of content – and alternately, to mistake image for content.

While he may not appear on the *Emigre* 64's radar, the most obvious conduit for this criticism is David Carson. Like Mies van der Rohe, David Carson is interesting precisely because he has not changed his

creative output since he began his design career. But this comment is unfairly reductive. Again like Mies, Carson's work has evolved by degrees, reflecting his own shifts in focus and changes in values. Conversely, while Experimental Jetset, Graphic Thought Facility and Foundation 33 appear to reject expressionism, to suppress the intuitive and subjective in favor of a reduction to content-driven systems, their practices hardly differ from those of the most celebrated artists. Foundation 33 recognizes a desire to claim authority over their own work by continually updating a record of design output on their website homepage – the contemporary equivalent of the artist's signature.

A more telling question would be to ask why, in the face of their own critical blindness, *Emigre*'s veteran critics can't find content in contemporary work but instead defensively manufacture categories of style? The activity of criticism is not one of judgment but an exercise in relations. I am not interested in setting limits to expression or proposing answers to the question of why designers choose the forms they do, mainly because I do not believe that such answers exist. I am interested in probing the meaning behind such choices. Critical writing begins by reflecting upon the culture and society that produces the work under scrutiny. It opens up possibilities, proliferates meaning, and mobilizes thought. This being the case, I look forward to output from the junior members of the theory and criticism club.

* Since writing this, Parsons School of Design in New York has begun a search for a full-time faculty position in design history/theory/design studies: "Parsons School of Design is currently redefining the role of critical and liberal studies in the design curricula. At the same time, the University is rethinking its provision of humanities and core teaching across the undergraduate curricula, developing new initiatives in these areas. These developments are giving a new focus to design history and theory and design studies, both in relation to the studio curricula in Parsons and as an academic field in its own right. Parsons School of Design and New School University have a very ambitious agenda for the next decade, including establishing design as a key intellectual as well as a studio discipline." The faculty member will be associated with the Department of Critical Studies, however, not the School of Design.

Sincerely,

DAVID CABIANCA

Typeface Index:

To order these
typefaces please visit
www.emigre.com

THE COVER AND TITLE PAGE DESIGN of this issue contain a medley of Emigre typefaces all based on historical models: from top to bottom they are: Filosofia, based on Bodoni; Eidetic Neo, based on a number of classical 20th century forms; Dalliance Script, based on an early 19th century hand lettering specimen; Fairplex based on American sign painting and display types of the late 19th and early 20th centuries; Mrs Eaves, based on Baskerville; Tribute, based on the 16th century letterforms of Francois Guyot; Vendetta, based on 15th century Venetian types; and finally Filosofia again. The back cover and spine were set in Fairplex. The Emigre script logo was designed by John Downer.

HALF-TITLE | Fairplex | DESIGNED BY ZUZANA LICKO

AaBbCcDdEeFfGgHhIiJjKkLl

TITLE PAGE VERSO | Vendetta | DESIGNED BY JOHN DOWNER

AaBbCcDdEeFfGgHhIiJjKkLlMmNn

DEDICATION | Solex | DESIGNED BY ZUZANA LICKO

AaBbCcDdEeFfGgHhIiJjKkLlMmNnOoPp

& Dalliance | DESIGNED BY FRANK HEINE

AaBbCcDdEeFfGgHhIiJjKk

CONTENTS LIST | Fairplex | DESIGNED BY ZUZANA LICKO

AaBbCcDdEeFfGgHhIiJjKkLl

PAGES 8-41 | Fairplex | DESIGNED BY ZUZANA LICKO

AaBbCcDdEeFfGgHhIiJjKkLl

PAGES 42-51 | Eidetic Neo | DESIGNED BY RODRIGO CAVAZOS

AaBbCcDdEeFfGgHhIiJjKkLlM

PAGES 52-61 | Fairplex | DESIGNED BY ZUZANA LICKO

AaBbCcDdEeFfGgHhIiJjKkLl

PAGES 62-87 | Tribute | DESIGNED BY FRANK HEINE

AaBbCcDdEeFfGgHhIjKkLlM

PAGES 88-95 | Filosofia | DESIGNED BY ZUZANA LICKO

AaBbCcDdEeFfGgHhIiJjKkLlMm

PAGES 96-111 | Tribute | DESIGNED BY FRANK HEINE

AaBbCcDdEeFfGgHhIjKkLlM

PAGES 112-127 | Filosofia | DESIGNED BY ZUZANA LICKO

AaBbCcDdEeFfGgHhIiJjKkLlMm